IMAGES
of America

CONCORD-
FARRAGUT

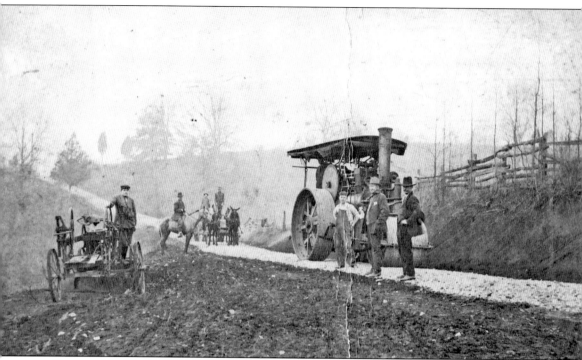

Kingston Pike (Highway 11-70) is the main artery that runs from Knoxville through Farragut. Highway 11 is the Dixie Lee Highway, and Highway 70 was known as the Broadway of America. Created in 1792, the pike saw many improvements over the years. In the early part of the 20th century, it was macadamized, a process in which the road is built up higher than the surrounding ground with tar or asphalt-like substances mixed with crushed stone. The crew has two kinds of horsepower—the living, breathing kind and the steam-powered kind. (Courtesy of Gary Scarbrough.)

ON THE COVER: Seven of the 16 grandchildren of Matthew and Julia Nelson Russell gathered on the stone wall in front of their grandparents' house in the Campbell Station (Farragut) community. Pictured about 1930 are, from left to right, Thomas Russell McFee, Caroline Russell, Ann McFee, Ann Russell, J. Frank Russell Jr., Robert Nelson McFee, and Julia "Judy" Nelson Boring. (Photograph by Henry F. Smith; courtesy of Mary Nell McFee.)

IMAGES
of America

CONCORD-
FARRAGUT

Doris Woods Owens
and Kate Clabough

ARCADIA
PUBLISHING

Copyright © 2009 by Doris Woods Owens and Kate Clabough
ISBN 978-0-7385-5374-0

Published by Arcadia Publishing
Charleston, South Carolina

Printed in the United States of America

Library of Congress Catalog Card Number: 2007940168

For all general information contact Arcadia Publishing at:
Telephone 843-853-2070
Fax 843-853-0044
E-mail sales@arcadiapublishing.com
For customer service and orders:
Toll-Free 1-888-313-2665

Visit us on the Internet at www.arcadiapublishing.com

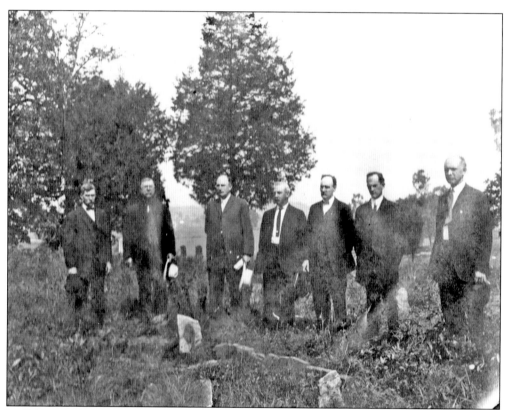

In 1918, a committee met to petition the state to erect a monument at the grave of Archibald Roane, second governor of Tennessee, whose home was at Campbell Station. The committee members are, from left to right, Will Hackney, G. D. Russell, unidentified, Matthew Russell, James F. Woods Jr., Rev. Rufus Gaines Reynolds, and Farragut High School principal Adams Phillips. (Courtesy of Kathlyn Boring Davis.)

CONTENTS

ACKNOWLEDGMENTS

I could never have attempted the work on this book without the help of Kate Clabough, who agreed to be coauthor. She has spent many hours scanning each picture, typing captions as I dictated, and serving as a proofreader. Despite living in a neighboring county, Kate has willingly made numerous trips to work with me. I deeply appreciate her support. Many thanks, too, to Kate's son Ian Fitz, who has been very helpful assisting his mother with the process of scanning more than 300 images.

I want to thank Paul Long, artist of the *Battle of Campbell's Station*, for permission to include a print of his painting.

Farragut Folklife Museum has been so helpful in making available many photographs and references. I was so familiar with the museum photographs that I thought the captions would take the least amount of my time, but I soon found that research was needed on almost all.

I wish to express my gratitude to those people whose names are noted with each caption. The following have not only contributed photographs but also have given vital information needed for interesting captions: Elbert Hale Heft, G. M. "Mac" Abel, Carl Bacon, Barbara Hall Beeler, Helen Trent, John Steele Campbell II, Carolyn Coker, Linda Laughlin Ford, Julia Cobb-Freer, David and Alicia Galbraith, Rebecca Goin, Byron and Gaines Harmon, Jennie Roberta Harvey Jones, Cleta Kincer Kelley, Carolyn Irwin North, Julia M. Scott, Tucker Montgomery, and Nelle Irwin Strange.

And last but not least, I want to thank my husband, Charlie, who acted as a proofreader and researcher and even took over many of my household duties while I was working on this project.

ABOUT THE AUTHORS

Doris Woods Owens, musician, teacher, and preservationist, was born in Concord. She moved to the Farragut area when her family was displaced by Fort Loudoun Lake. A graduate of Farragut High School, she earned a bachelor's degree in home economics education from the University of Tennessee and a master's degree in administration, supervision, and curriculum from the University of Northern Colorado.

After serving 20 years as an educator in Miami, Florida, Owens took early retirement in 1982 to return to her home in Farragut, where she helped to organize Farragut Folklife Museum, serving 21 years as a volunteer with 15 years as its director. She retired in January 2008 to finish this book. Owens lives in Farragut with her husband, Charlie. Two daughters and two granddaughters live close by.

Kate Clabough is a professional freelance writer, historian, genealogist, and former librarian. A native of Nebraska, Clabough moved to East Tennessee in 1997. She and her husband, David, daughter, Kacy, and son, Ian, make their home in the foothills of the Great Smoky Mountains.

INTRODUCTION

When I chose the title *Concord-Farragut* for this book, it was my intention to show how two diverse communities could be thought of as one. The original settlement of 1787 was called Campbell Station for the family who settled there following the Revolutionary War. It was never considered a town; rather it was an area of large farms where houses were widespread. A few businesses sprang up offering the necessities to the families that settled in the area. In 1852, the East Tennessee and Georgia Railway, establishing a line between Chattanooga and Knoxville, purchased a right-of-way two miles south of Campbell Station.

James Martin Rodgers, owner of much of the land along the railroad, saw the advantage of a possible rail center along the river port. He laid out 55 lots, creating a town he called Concord. The town grew rapidly after the first lot was sold in 1855. A post office was commissioned to serve the people, not only of the community of Concord, but of Campbell Station and much of the surrounding areas as well. The railroad established freight and passenger service for the Concord area and also carried incoming and outgoing mail. Churches were established in Concord, and businesses came into the new town, many coming from Campbell Station. In early 1882, several marble quarries were opened in the area, and Concord became a large rail center for shipping marble to many destinations throughout the country. Some of the quarries located on the Tennessee River used barges to get their marble slabs to the rail connection.

In the early years, having no public school building, elementary and secondary classes were held on the first floor of the Concord Masonic Hall. Many parents sent their older children by train to Knoxville for their high school education. Others were unable to do so for economic reasons and for the loss of labor on the family farms.

By 1900, it became apparent that a high school was needed for students of the Concord–Campbell Station area. A committee was formed in 1902, made up of representatives of both communities, to plan, build, and operate a high school. The site chosen was in Campbell Station, where acreage was needed for the school's agricultural program. The educational programs, which included agriculture and home economics, were geared to students from the surrounding farms. Special drama presentations and sports events were always well attended by both communities. The new school was named Farragut in honor of Adm. David Glasgow Farragut, the first admiral in the U.S. Navy and hero of the Civil War. He was born just a few miles from the school site.

The two things most responsible for making the two communities one was the Concord post office, with its sprawling rural routes reaching to Rocky Hill on the east, Loudon County on the southwest, and Hardin Valley on the north, and the school enrollment, which also included students from the same areas.

In January 1980, the area formerly known as Campbell Station was incorporated and became the town of Farragut. By this time, the post office had been moved from Concord to Kingston Pike, which is the main thoroughfare from Knoxville, as the traffic of commerce evolved from river and rail to highway.

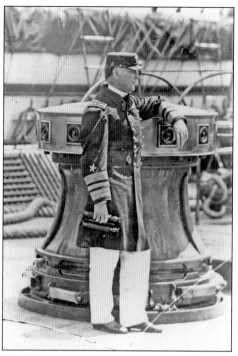

Adm. David Glasgow Farragut, first admiral of the U.S. Navy and Civil War hero, was born about 5 miles from Campbell Station. The photograph was taken of Admiral Farragut on the deck of the USS *Franklin* on his cruise to Europe during a goodwill tour following the Civil War. His flagship, when engaged in the battles of New Orleans and Mobile Bay, was the USS *Hartford*. After these engagements, President Lincoln created the rank of admiral for Farragut, but Lincoln was assassinated before it could become official. It was Pres. Andrew Johnson, another Tennessean, who signed his commission. (Courtesy of Farragut Folklife Museum Collection.)

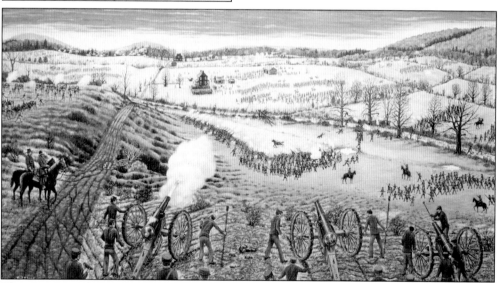

This painting, *The Battle of Campbell Station* by local artist Paul Long, hangs in the rotunda of the Farragut Town Hall. The painting depicts the Civil War battle fought on November 16, 1863, in what is now Farragut. Confederate general James Longstreet was ordered to retake Knoxville from the Union forces, commanded by Gen. Ambrose Burnside. Learning of Longstreet's orders, Burnside mustered about 5,000 men and arrived at Campbell's Station with only minutes to spare. He set up defenses along Concord Road and north of Kingston Pike. Heavily outnumbered, the Union forces repulsed three charges by the Confederates. After nightfall, General Burnside quickly retreated to Knoxville. Burnside's delaying tactics in holding Longstreet for one day at Campbell's Station allowed the troops in Knoxville much needed time to prepare Fort Sanders for the coming battle and siege of Knoxville. (Courtesy of Farragut Folklife Museum Collection.)

One

FARMS, BUSINESS, AND TRANSPORTATION

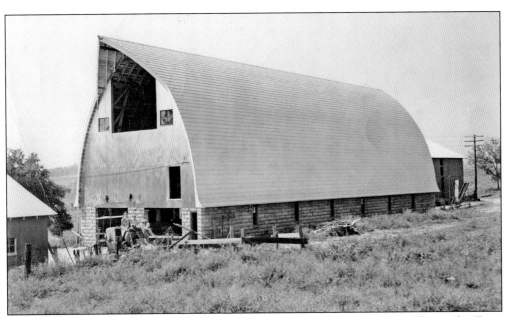

In 1947, Robert Nelson Bacon started building a barn with many innovations, calling it the "Barn of Tomorrow." He wanted a barn without supports to get in the way. Other ideas were offered by farm workers and other farmers. It was designed by Frank Kincer, and all lumber for the building came from trees on the Bacon farm. The aluminum roof, guaranteed for 200 years, was supplied by the Reynolds Aluminum Company. Concord inventor Jesse Benson designed a hoist and hay sling with a capacity to carry 27 bales to storage at once. With 16,000 bales stored, it still was not filled to capacity. At a cost of $15,000, it took five years to complete and only a few days to demolish in 1987 to make way for Willow Creek Golf Club. It gave 40 years of exceptional service before becoming the "Barn of Yesterday." (Courtesy of Carl Nelson Bacon.)

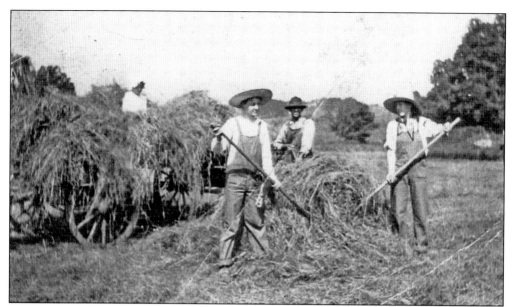

With a shortage of men during World War I, many women had to take on some of the heavier farm work. With no sons in the John Welch family, daughters Ziza (right) and Clara work in the hay with an unidentified neighbor. Their mother, Viola Rogers Welch, waits on the wagon. (Courtesy of James Welch Woods.)

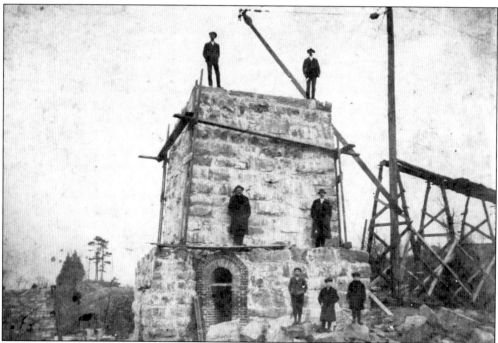

The C. B. Neuhouser lime kiln, built on Dutchtown Road about 1879, was a good distance from the Neuhouser house and spring. Lime was used primarily by the farmers to help stabilize the soil. Whitewashing trees with a lime solution was used as a protection from insects. It was also thought to be decorative and leave a clean appearance. (Courtesy of Farragut Folklife Museum Collection.)

The older barn on the Robert Nelson Bacon farm was used for air-drying burley tobacco. After cutting in August, the tobacco would hang in the barn until November. It would then be taken to the Knoxville Western Avenue Market, where it would be graded and auctioned. Bacon's tobacco always sold for top prices. (Courtesy of Carl Nelson Bacon.)

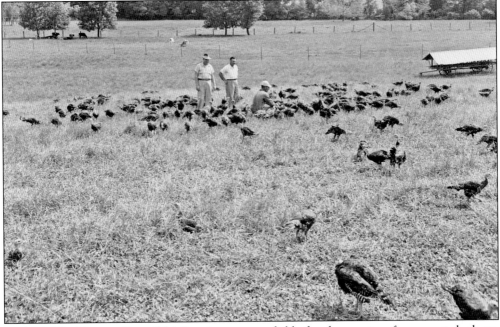

In the 1970s, Thomas Russell McFee sits among a field of turkeys as two farm agents look on. Following his retirement from the University of Tennessee veterinary school, Tom managed the large family farm, which grew tobacco and other crops. Turkeys and tobacco were the money-making crops until the cost of feed became so high he closed the turkey business. After Tom McFee's death in 1986, his brother Alfred and sister Anne Shipley (from whom this information comes) managed the farm until it was sold to developers in 2006. (Courtesy of Farragut Folklife Museum Collection.)

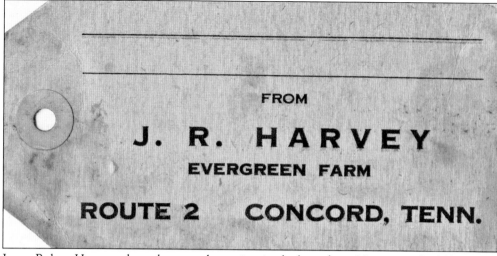

FROM

J. R. HARVEY

EVERGREEN FARM

ROUTE 2 CONCORD, TENN.

James Robert Harvey, a hat salesman, also maintained a large farm. He grew and sold boxwood shrubbery under the name of Evergreen Farms. Boxwoods were trimmed and the cuttings sold for replanting. More mature boxwoods were landscaped around his house. Evergreen Farm was located on Harvey Road. (Courtesy of Roberta Harvey Jones.)

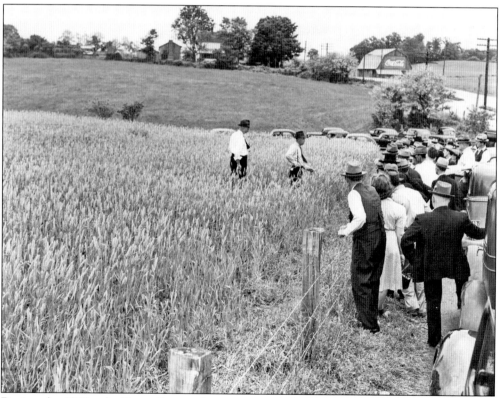

During the 1940s, the Knox County farm agent and the University of Tennessee Extension Service scheduled field trips to see farm improvements. Agent R. M. Murphy stood in front (left) as he introduced Robert Nelson Bacon, who told how he enriched soil by growing red clover then plowing it under to improve fertility. (Courtesy of Carl Nelson Bacon.)

Hackney Mill, built in the late 1800s on Turkey Creek, was located near Concord and North Loop Roads. William Hackney, owner and operator, did not have the conventional mill with a waterwheel to supply power. The energy to run this mill came from a water turbine. (Photograph by Henry F. Smith; courtesy of Farragut Folklife Museum Collection.)

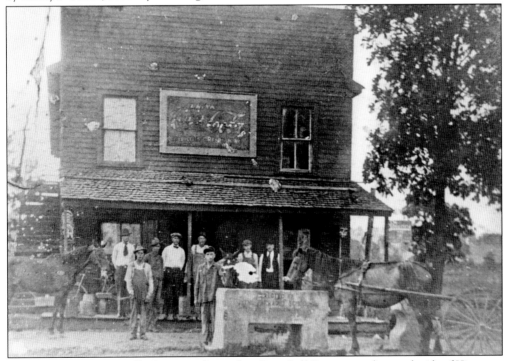

In the early 1900s, Russell's Store was located at Campbell Station on the north side of Kingston Pike near Concord Road. The store was operated by M. L. Russell and later as M. L. Russell and Sons. In the late 1920s, the store was washed from its foundation by flooding Turkey Creek. To avoid future floods, the store was relocated a few yards east. (Courtesy of J. Frank Russell Jr.)

13

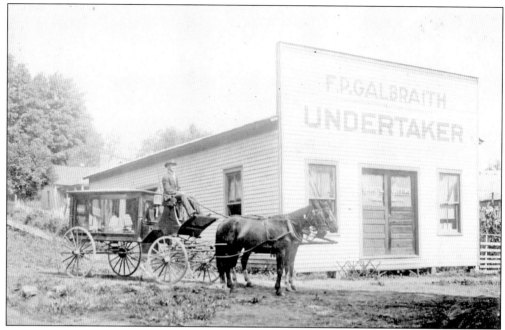

Concord's undertaker, Franklin Pate Galbraith, had his wife, Mayme Low Galbraith, as his helper. She also sent obituaries to the Knoxville newspapers. The horse-drawn hearse had been used in Gov. Archibald Roane's 1801 gubernatorial parade. (Photograph by Henry F. Smith; courtesy of Mary Nell McFee.)

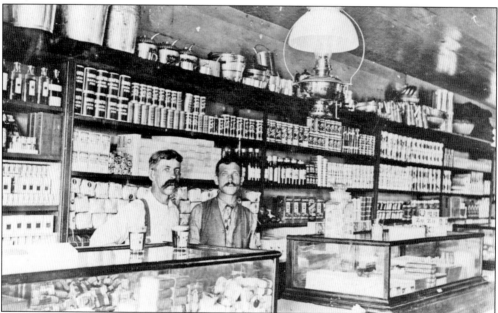

John G. Welch (left) and Lee D. Hobbs were partners from 1909 to 1921 in the Concord General Merchandise Store, located in the two-story stone building. The picture shows well-stocked shelves. Before electricity was available in Concord, they relied on kerosene lamps. An interesting feature in the rear of the store was a hand-operated elevator. (Courtesy of James Welch Woods.)

Concord Marble Quarry on Calloway Ridge was pictured in 1915 while being operated by the J. F. Woods Marble Company. After working the marble quarry at Cedar Bluff in the 1880s, Woods moved to the quarry at Concord, where a marble sawmill and a finishing shop were included. (Photograph by Henry F. Smith; courtesy of James Welch Woods.)

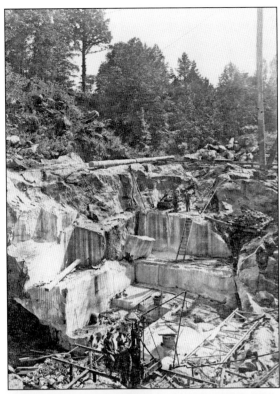

Pictured at the Concord marble sawmill, from left to right, are James Farmer Woods Jr., his son Walter, and an unidentified stonecutter. After sawing, the smaller slabs of marble would be taken to the finishing shop at the corner of Church Street and Second Drive. (Courtesy of James Welch Woods.)

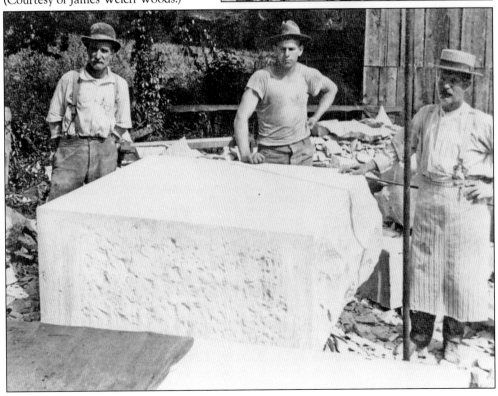

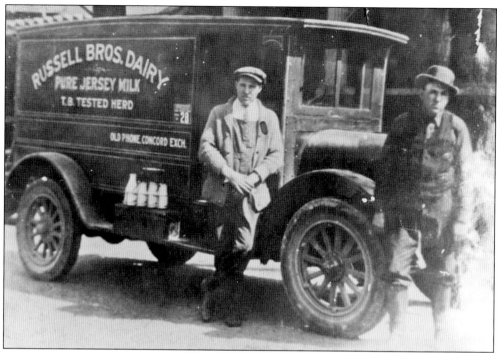

In the mid-1920s, brothers Avery and Charles Russell owned and operated the Russell Brothers Dairy. Avery lived in the Campbell Station–Farragut area, and Charles had a farm on Concord Road. In the picture, a helper on the truck, Clifton Raby (left), stands with Avery Russell. (Courtesy of Robert Russell.)

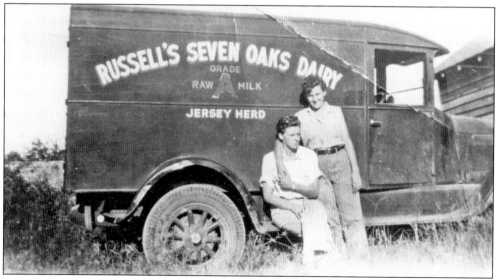

Russell's Seven Oaks Dairy was owned and operated by Charles Russell on Concord Road. In the mid-1920s, he was in partnership with his brother, Avery. They later split, and each operated his own dairy business. Charles's daughters, Katherine (left) and Clara, helped when sons were unavailable. (Courtesy of Farragut Folklife Museum Collection.)

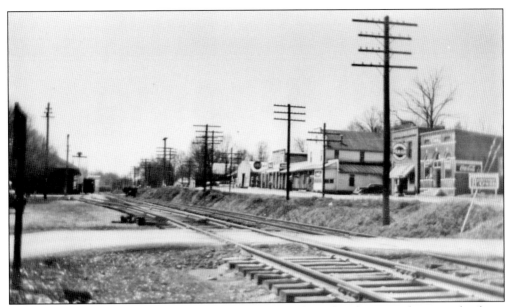

This 1942 photograph of Concord's Front Street shows the railroad running between the depot and the business district. There were three grocery stores, a barbershop, a restaurant, a library, and a garage in the former livery stable. It was used to service buses of the local Fox Motor Coach Lines. (Photograph by TVA; courtesy of Gene McNutt Abel.)

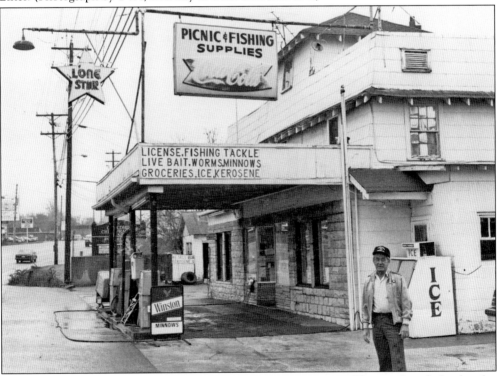

The Lone Star, a service station and convenience store, was one of Farragut's early landmarks. Oscar Woody of Concord established the station in 1925. One could buy light groceries and hunting and fishing licenses as well as fishing bait. (Courtesy of Farragut Folklife Museum Collection.)

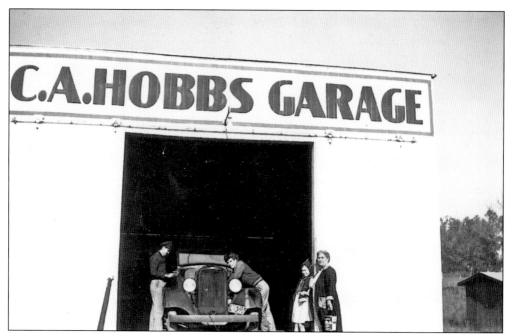

The C. A. Hobbs Garage was located on Kingston Pike west of Everett Road. Pictured around the automobiles in the late 1930s are Bill Everett (left) and Robert Hobbs. Josie Emory Hobbs (right) and Edna Hobbs Ivey wait by the door. (Courtesy of Edna Hobbs Ivey.)

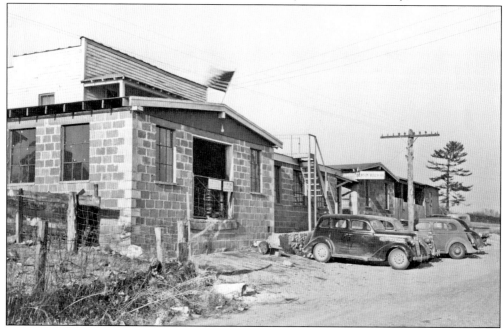

Benson Winch Company, located on Westlyn Drive east of Concord Village, made some hasty construction to enlarge the existing plant in 1942. Jesse Benson, owner of the plant, was given a government contract for winches that he had designed. Benson winches are still in use by the navy for various jobs, including lowering and raising the anchors on many vessels. (Courtesy of Charles Warren Benson.)

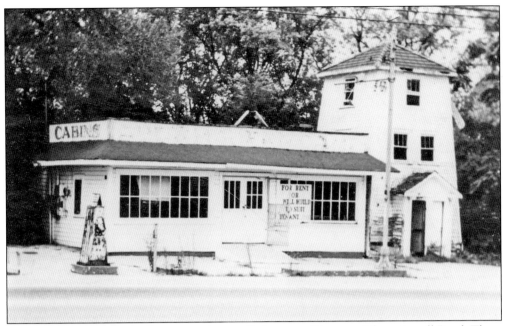

Aud's Camp, or simply Aud's as it was later called, was on Kingston Pike at Lovell Road. There were tourist cabins on the north and east sides of this building. During the 1930s, there was a demand for overnight accommodations as long-distance travel by automobiles increased. Other tourist courts were located along Routes 11-70 through Farragut. (Courtesy of Farragut Folklife Museum Collection.)

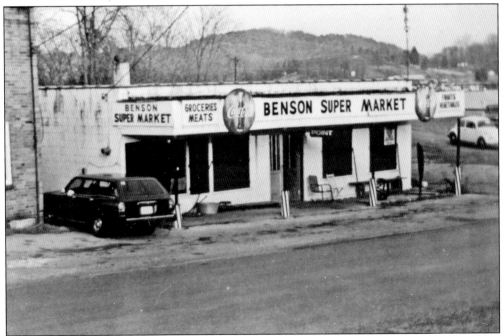

Benson Super Market was established in 1947 on Olive Street in Concord by Charles and Pauline Benson. It was the last grocery store to serve the village of Concord. In the 1970s, its doors were closed for good. (Courtesy of Farragut Folklife Museum Collection.)

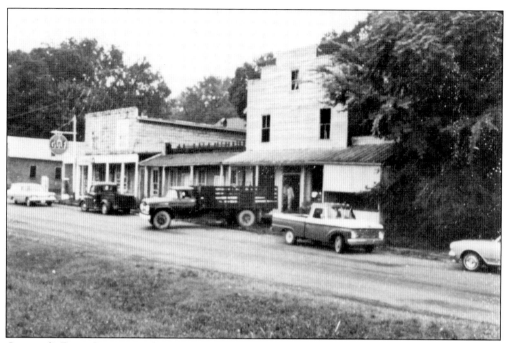

Concord's Front Street was about to get a new look. The old frame store and covered boardwalk were being razed when this picture was made in 1967. They were being cleared to make way for a new post office that was to be built. (Courtesy of Freddie Smith Cannon.)

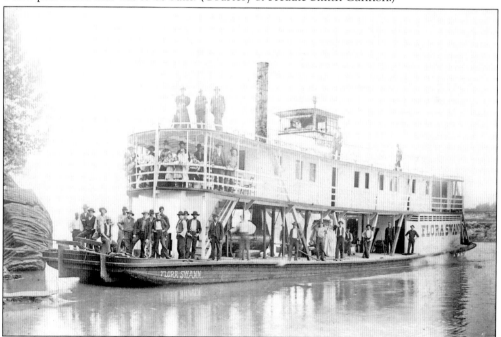

The *Flora Swann*, a paddle-wheel riverboat, traveled between Loudon and Knoxville, making the necessary stops along the way. As noted in a diary of Loudon attorney Hugh Mason McQueen, "The boat stopped at Callaway's Landing at Concord where a delicious dinner was served by Mrs. Callaway." (Courtesy of Elbert Hale Heft.)

The U.S. Mail carrier out of Concord Post Office, as late as 1919, delivered mail by horse and cart. This photograph shows Samuel McSpadden on his mail route. He enjoyed riding his bicycle to deliver the mail when the weather permitted. (Courtesy of Farragut Folklife Museum Collection.)

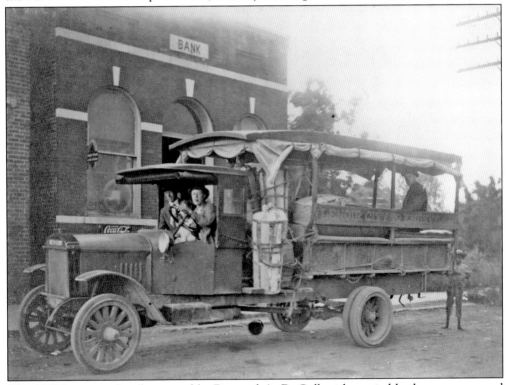

The 1918 bus owned and operated by Roy and A. D. Galbraith carried both passengers and produce. The curtains along the sides could be closed when it was cold or raining. The bus is parked in front of Concord Bank, one of its stops between Lenoir City and Knoxville. (Courtesy of David and Alicia Galbraith.)

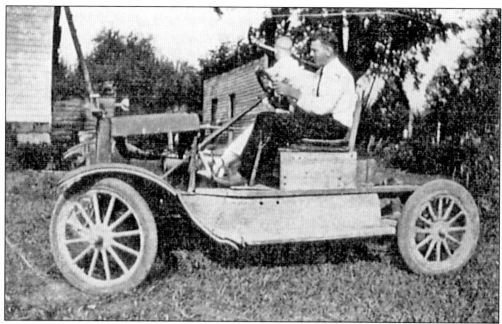

In 1922, Walter Gordon Woods sits proudly behind the wheel of his first automobile. Woods, a four-year rural mail carrier for Concord Route Three, had traded a good horse and buggy for this "super model." Over the next 43 years, his shopping skills were improved. He never again purchased a convertible. (Courtesy of James Welch Woods.)

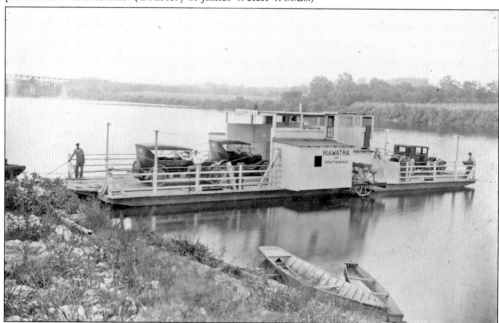

The ferry loaded with automobiles in the 1920s was located at Loudon. Before a bridge was constructed, the ferry was a connection for U.S. 11 to Chattanooga and points between. Low's Ferry, about four miles east of Concord, was a connector to Blount County. Many people of Concord and Farragut with families, businesses, or travel needs depended on these two ferries. (Courtesy of Elbert Hale Heft.)

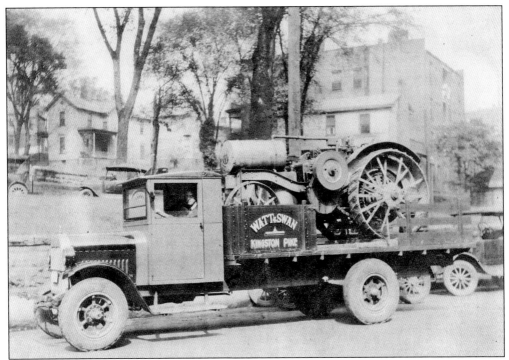

A trucking company located on Kingston Pike in the Union community of what is now Farragut was operated by members of the Watt and Swan families. This picture, taken about 1930, shows driver Paul Swan transporting a load of heavy equipment. Swan also collected large cans of milk from local farmers to deliver to a dairy. (Courtesy of Paul Russell Swan.)

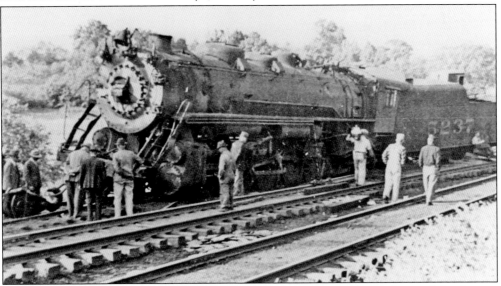

In 1941, a derailment at Concord of a Southern Railroad locomotive and several freight cars caused great concern. None of the crew was injured, but many sheep were injured when the stock car they were in overturned and split open on impact. The sheep scattered over the fields, some running blindly because of head injuries. This wreck was the result of several young boys placing a railroad spike on the rail. (Courtesy of Harlan F. Dunlap.)

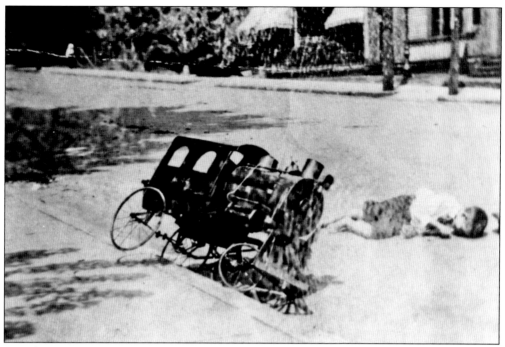

Derailments were not uncommon to Concord-Farragut folks, especially those with a sense of humor. While in Knoxville in 1914, young Charles Boyd Fritts succeeded in entertaining all who were watching. (Courtesy of Lee Fritts.)

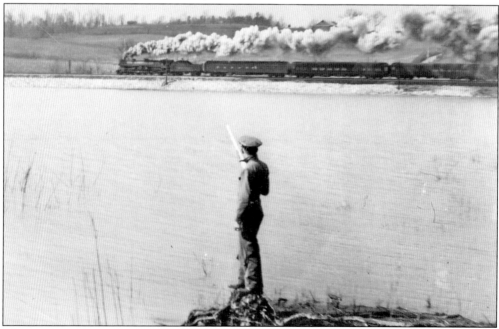

Elbert Hale Heft, a Concord soldier home on furlough during World War II, found most of the farm he had grown up on had become part of the backwaters of Fort Loudoun Lake. He stood on a point of his family's land not yet under water and watched a Southern Railroad passenger train on its run to Chattanooga. (Courtesy of Elbert Hale Heft.)

Two

BUILDINGS AND HOUSES

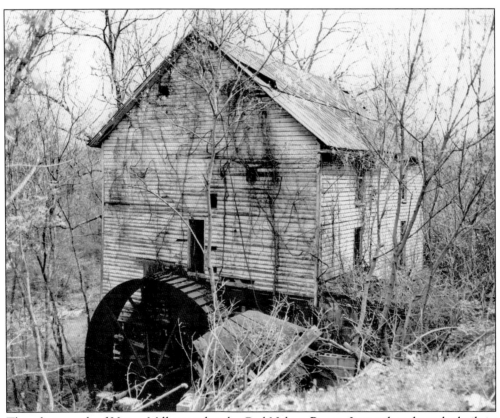

This photograph of Virtue Mill was taken by Carl Nelson Bacon. It was thought to be built in the 1840s or 1850s. It was located on the creek side of Virtue Road. There was a movement to preserve the mill and have it placed on the National Register of Historic Places. While plans were being made for its restoration, Virtue Mill was destroyed by fire on June 2, 2002. (Courtesy of Carl Nelson Bacon.)

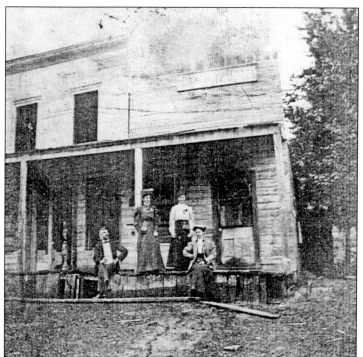

This building dates to the early years of Campbell Station Inn. It was the early blockhouse and was used later for an overflow of guests. In the early 1900s, Frank Kollock of Hardin Valley razed the building and hauled it by wagon over twisting and hilly Campbell Station Road to Hardin Valley Pike. It was rebuilt on Kollock's Corner and used as a store for many years. (Courtesy of Jane Farnham Taylor.)

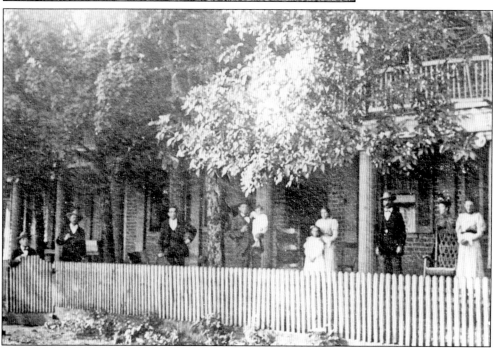

The Campbell Station Inn, built in the late 1790s, is still a residence. Members of the Russell family have lived in the house since 1858. The Avery Russell descendants are the last to occupy the house. A major change was made when the double front porches were removed and replaced by a small covered entrance. The stately columns were used on a home located on Clinch Avenue in Knoxville. (Photograph by Carl Bacon; courtesy of Anna Mae Russell.)

After the Russell brothers dissolved their dairy business in the early 1930s, each started his own dairy business. Avery Russell built this dairy building behind his house on the corner of Campbell Station Road and Kingston Pike. Besides the dairy plant, it also included an office and a garage for servicing the milk trucks. When Russell was no longer in business, the office was leased to other parties, including, from 1984 until 1991, the new Town of Farragut's staff. (Courtesy of Farragut Folklife Museum Collection.)

The Farragut Library was started with a few shelves in a corner of Russell's Store. It was set up and attended by the Farragut Woman's Club, opening one day a week. Eventually they purchased one of the prefabricated houses being auctioned at Oak Ridge. It was placed on the Farragut High School campus. Eleanor Thompson was the first librarian. The Farragut Library ceased operation when Knox County constructed a library at Lovell. (Courtesy of Farragut Folklife Museum Collection.)

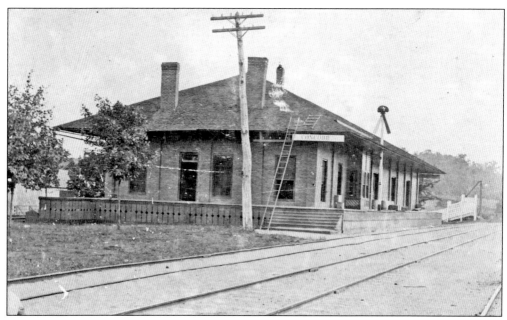

Concord's Southern Railroad Depot in this 1905 photograph appears to be without passenger or freight business. Actually, until the mid-1930s, the Concord depot was the most active station between Knoxville and Chattanooga. When passenger service was discontinued, freight and mail service continued until trucks started serving the local postal offices. (Photograph by Henry F. Smith; courtesy of the Farragut Folklife Museum Collection.)

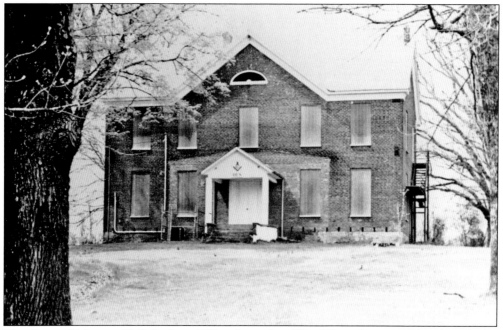

The Concord Masonic Hall, built in 1870, is located on Third Drive between Church and Clay Streets. The Masons held their meetings on the second floor. Over the years, the first floor has been used as a school, a polling place, and a weekly movie theater. The Masons now occupy both floors. (Courtesy of Harlan Frederick Dunlap.)

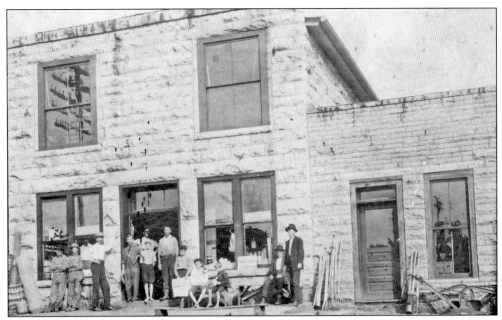

It is thought that, in 1890, S. A. McNutt built a one-story stone store in Concord on the corner of Clay Street and Front Street (the present Lake Ridge Drive). About 1895, he added a second story to the building, and a slight difference in the shade of the marble is noticeable between the two stories. Remaining near the street is a large marble block called an "upping block," used for mounting horses or carriages. (Courtesy of Gene McNutt Abel.)

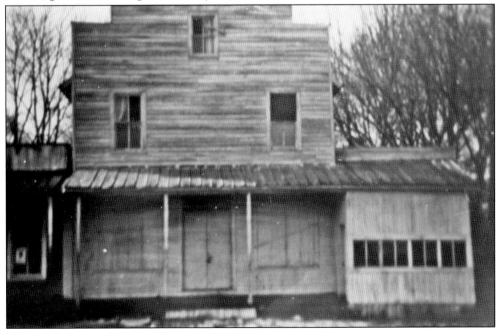

Concord's first permanent library can be seen on the right of the porch of E. Sharp's store. In the early 1930s, Lawson McGhee's "Library on Wheels" served Concord monthly, but the community needed a permanent place. Shelves were built and filled with books to interest all ages. (Courtesy of Freddie Lee Smith Cannon.)

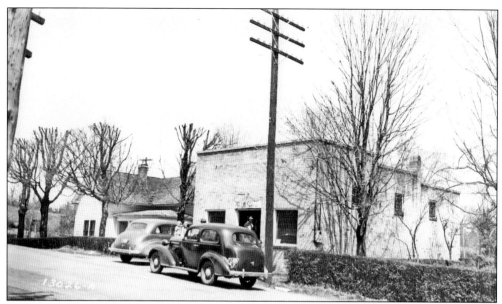

The location of the Concord Post Office was determined by which political party was in power. There were two sites used in the 1930s and 1940s. The two large rooms on the covered boardwalk connecting two Front Street stores served first. The brick building on Olive Street was much larger and better served the growing community. (Courtesy of Gene McNutt Abel.)

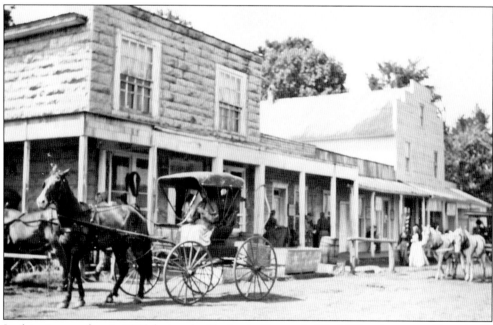

In this picture taken in 1965 during the filming in Concord of *Fool Killer*, the covered boardwalk connecting two buildings can easily be seen. Two large rooms on the boardwalk have been used as a U.S. post office or rented as a small apartment. Soon after this picture was taken, the boardwalk and frame buildings were razed to provide space for a new Concord Post Office. (Courtesy of Elbert Hale Heft.)

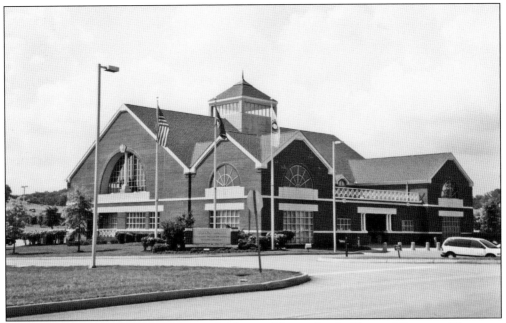

Farragut Town Hall, built in 1991, was the first real home for the Town of Farragut. The town incorporated in 1980 with very little operating funds, so office space had to be leased. In the new building, space is available for the town's various departments, a meeting room, a large rotunda, and Farragut Folklife Museum. (Courtesy of Doris Woods Owens.)

This 1860 two-story dwelling is thought to be the first house built and still standing in Concord. When the lot was sold at public auction in 1866, it was described as having a dwelling. It is located on the southeast corner of Clay Street and Second Drive opposite Concord Presbyterian Church. (Courtesy of Gene McNutt Abel.)

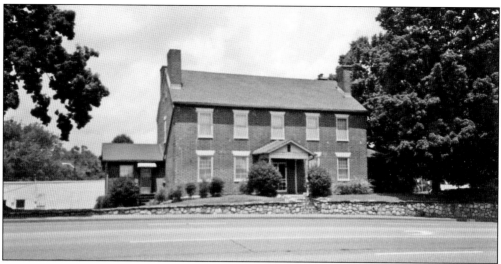

Campbell Station Inn was built in the late 1790s by Col. David Campbell, founder in 1787 of Campbell's Station. The inn was not only for hosting dignitaries but also for drovers taking their livestock to market, hunters, traders, and people traveling through to other settlements. In 1824, Colonel Campbell sold the inn and all of his holdings to Samuel Martin. The double front porches were removed and replaced by a small covered entrance. The stately columns were used in a Clinch Avenue house in Knoxville. (Photograph by Carl Nelson Bacon; courtesy of Anna Mae Russell.)

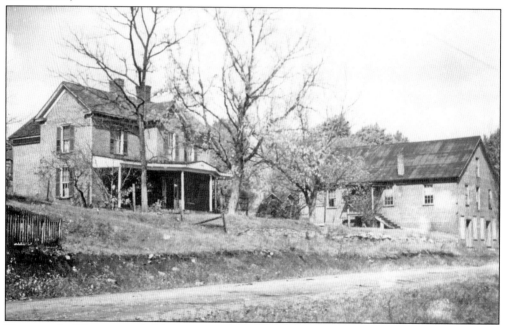

These two buildings are probably best remembered as the Plumadore Inn and the Plumadore Brick. Originally in 1883, Dr. E. S. Rogers and his wife, Bettie, purchased a tract along Front Street in Concord. They built their residence, and to the east, the doctor built a three-story infirmary, both of bricks made from local clay. By 1902, George and Eva Plumadore acquired the two buildings, conveniently near the railroad depot. The residence became the inn, and the other building was used for guest overflow. Later it was used for rental property. (Courtesy of Bill S. Dunlap.)

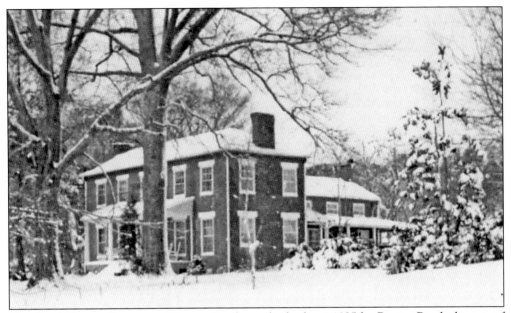

The Boyd-Harvey House, on Harvey Road, was built about 1835 by Baxter Boyd, the son of Revolutionary War veteran Thomas Boyd. The bricks were made by Boyd family slaves. Unusual features were used in the construction. The front second-floor bedrooms are separated from the room in the rear wing by a solid wall, as are the two large rooms in the back wing over the kitchen. There are three staircases, one for each section. (Courtesy of Roberta Harvey Jones.)

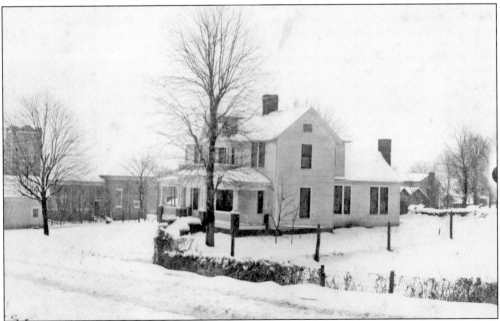

The large two-story house on Olive Road in Concord was built in 1885 by Dr. Spencer Rodgers and his wife, Cordelia Haun Rodgers. The property was sold in 1892 to Dr. James A. Mourfield and his wife, Mary. Again, in 1920, the house and lot with a two-room doctor's office was sold to Dr. Carl Henry, who made renovations in the interior and extensive changes to the front of the house. (Photograph by Henry F. Smith; courtesy of Barbara Beeler.)

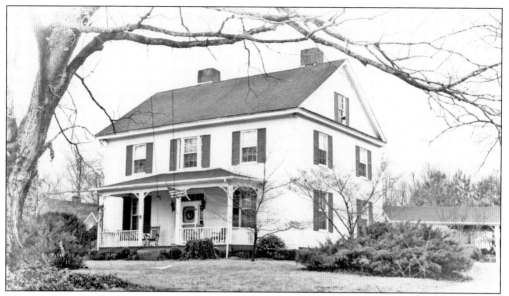

This magnificent house was built about 1866 by Edmund H. Haun for his wife, Ann Elizabeth Smith, and 11 children. Situated high on Concord Hill at Olive Road and Third Drive, the home has a clear view of the Great Smoky Mountains. In 1873, Samuel and Amanda Rodgers Russell purchased the house. Their three unmarried daughters continued to live there. In 1942, the two remaining sisters sold the house. Gene McNutt Abel is the present owner. (Courtesy of Gene McNutt Abel.)

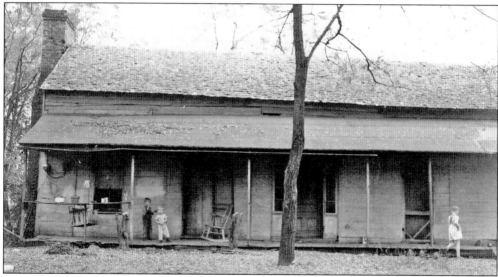

This house, known as the McClung House, was located near Campbell Station on the McClung Plantation. It was later known as the Robert N. Bacon farm and is presently the Willow Creek Golf Club. It was built about 1798. Around that time, Charles McClung was in partnership with Col. David Campbell in a mercantile business at Campbell Station. Originally the house was built with a dogtrot, but in later years, it was enclosed. The old Stage Road ran in front of the house. An unusual walkway of handmade bricks, laid in a herringbone pattern, stretched to the road. When Bacon built his new house in 1925, he left the old house in place, and the families of the farm workers lived in it. (Courtesy of Carl Nelson Bacon.)

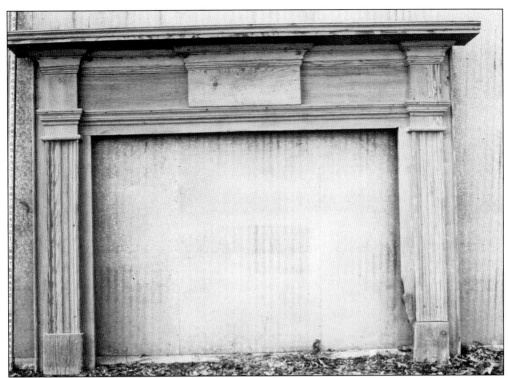

This mantel taken from the McClung House at Campbell Station measures 5.5 feet high and 8 feet wide. Note the detailing on the side posts and crosspiece. This indicates that the McClung House was not a primitive cabin as so often seen around the early settlements. Before the house was taken to the Museum of Appalachia, Carl Bacon incorporated the mantel, doors, and other items in his own house in Gatlinburg. (Photograph by Carl Nelson Bacon.)

The Campbell-Nelson-Russell House was built about 1820 by John Campbell, son of Col. David Campbell, founder of Campbell's Station. It had several owners before Dr. William Nelson acquired it prior to the Civil War. The house served as a hospital during the Battle of Campbell's Station on November 16, 1863. Dr. Nelson attended the wounded, both Union and Confederate. Over the years, the house was easily recognized; it now peeps over commercial development and is frequently identified as the "House behind Taco Bell." (Courtesy of J. Frank Russell Jr.)

The P. W. Bevins house was located on Kingston Pike opposite the Campbell Station Inn (later known as the residence of Avery Russell). Bevins and his family of nine children relocated from Virginia looking for a place to live near a good high school. Although they lacked modern Internet search engines, the Bevins family heard about Farragut High School and was fortunate enough to find a three-story house less than a mile away. A 10th child, Wilda, mother of current Farragut mayor Eddie Ford, was born in Tennessee. The Bevins property included three adjoining farm properties and was eventually distributed among the children. (Courtesy of Linda Laughlin Ford.)

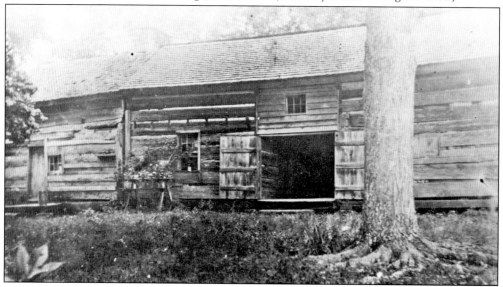

This log house was built in 1810 on Harvey Road by Revolutionary War veteran "Elder" David Campbell. He was a cousin of Col. David Campbell, founder of Campbell's Station. The farm and old log house have served three generations. Andrew Lamar Campbell replaced the log home in 1916 with a large white farm house. He retained the center portion of the original house to serve as a garage, but that, too, has been replaced. (Courtesy of John Steele Campbell II.)

Three

PEOPLE, EVENTS, AND RECREATION

Henry Franklin Smith, whose parents were Joseph and Rebecca Lucy Smith, was born at Concord in 1875. The Lucy family lived in Possum Valley near Harvey Road. Like his father, Henry's occupation was that of a stonecutter. Before 1900, Henry had already become fascinated with the camera. He took pictures of families, buildings, and events in Campbell Station–Concord and throughout the area. Many of the images in this book were made by Smith, including the cover photograph. (Courtesy of Barbara Hall Beeler.)

Robert Edgar Boring was born in 1871 to Joseph Albert and Nancy Griffitts Boring. The family came from Blount County to settle on a large farm in the Campbell Station area. Robert attended Friendsville Academy. At the age of 23, he married Annie Hackney. Boring has been involved in farming, merchandising, and real estate, has served eight years as criminal court clerk, and, most of all, he was a man for his community, serving more than 30 years on the school board, including 12 years as chairman. Boring served as Sunday school superintendent of the Concord Methodist Church for 18 years. (Courtesy of Farragut Folklife Museum Collection.)

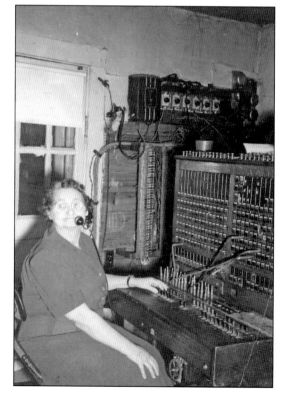

Rhetha Hammond, Concord's longtime telephone operator, sits at her switchboard. In an emergency, one could always depend on Hammond to get help. She was an early 911 call. Even when she was sleeping, the switchboard was set to ring. (Courtesy of Farragut Folklife Museum Collection.)

W. M. FOX

Will Appreciate Your Vote and
Support for Re-election for

JUSTICE OF THE PEACE

10th DISTRICT

 5

Election, August 7, 1930

William McCamey Fox Sr. was so well liked in the area that he had no trouble gaining votes from both political parties when he was running for Knox County justice of the peace. He was reelected and served in that office for many years. (Courtesy of Wilma Donovan Benson.)

Capt. Wayne Raby is shown in January 1967 at his recent promotion to captain in the Tennessee Highway Patrol. He joined the patrol in 1941 but took a leave from 1942 to 1946 for army service. Born in the Campbell Station area, Raby graduated in 1934 from Farragut High School, where he was on the basketball team. (Courtesy of Carolyn Coker.)

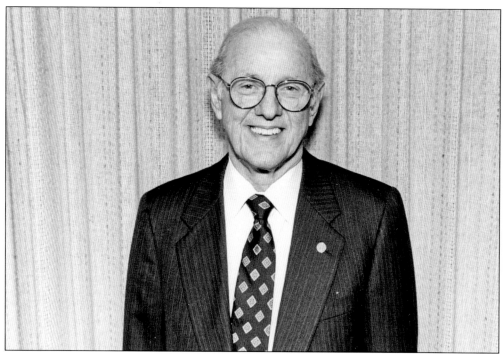

Robert Leonard, an attorney, grew up in South Knoxville. In the 1960s, Bob and his wife, Marie, moved west to Village Green, the new subdivision in the country just west of Campbell Station Road. When the town of Farragut was incorporated in 1980, Robert Leonard was elected its first mayor. He served until 1993. He was instrumental in starting Farragut Folklife Museum. (Courtesy of Farragut Folklife Museum Collection.)

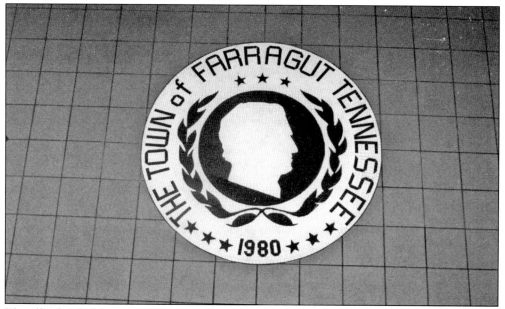

The official seal of the town of Farragut is done in mosaic tile on the floor in the center of the rotunda at Farragut Town Hall. It shows the date of the town's incorporation and a silhouette of Adm. David Glasgow Farragut, the town's namesake. (Courtesy of Farragut Folklife Museum Collection.)

Mayor Walter Edward "Eddie" Ford III, son of Walter and Wilda Bevins Ford, attended Farragut schools, where he was valedictorian of his 1957 class. He earned both bachelor's and master's degrees in nuclear engineering. Mayor Ford retired after 33 years, first with the U.S. Atomic Energy Commission and later with the Computational Physics and Engineering at Oak Ridge National Laboratories. (Courtesy of Farragut Folklife Museum Collection.)

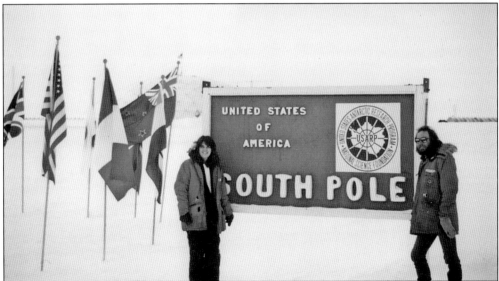

Tennesseans Michael and Mary Bates were considered newcomers, as they came to Farragut when farms were turning into subdivisions. In fact, they have helped plan and build houses in the area. They have shared with the community through exhibits and lectures about some of their early experiences and service as young explorers on the continent of Antarctica. Michael served seven seasons and Mary three times on the coldest continent. After their marriage in New Zealand in 1982, Michael received another assignment as Siple Station coordinator and Mary was assigned as cook and communication and meteorological operator. (Courtesy of Michael and Mary Bates.)

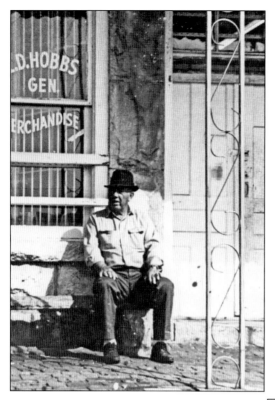

Russell Hobbs, son of Lee and Lena McReynolds Hobbs, rests on the "loafers" bench in front of the L. D. Hobbs store in Concord. After his father's death, Russell operated the store with his mother. Russell was an avid hunter and also enjoyed fishing on Fort Loudoun Lake. He took great pleasure in telling a few of his stories when he had a captive audience. He was married to Ruby Fox. (Courtesy of Doris Woods Owens.)

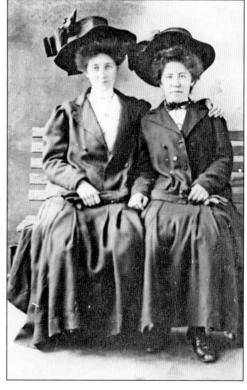

Ella McKay (left) and Lula Tudor have met again after many years. They dressed in their finest for the occasion. The girls were best friends when they attended Richland School at Lovell from about 1905 to 1907. (Courtesy of Farragut Folklife Museum Collection.)

Matilda Keller Benson, born December 26, 1849, was married to Charles Wesley Benson, a blacksmith. In 1881, their son, Jesse Mack, was born in Scarborough, Anderson County, Tennessee, before the family moved to Concord. Matilda had been married before to a Bowman. She had a son, John, from that marriage. Matilda died January 24, 1922, and is buried in Concord Masonic Cemetery. (Courtesy of Charles Warren Benson.)

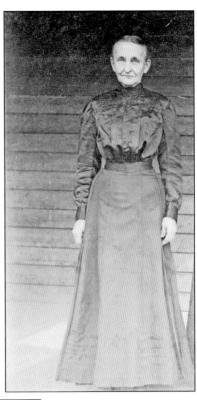

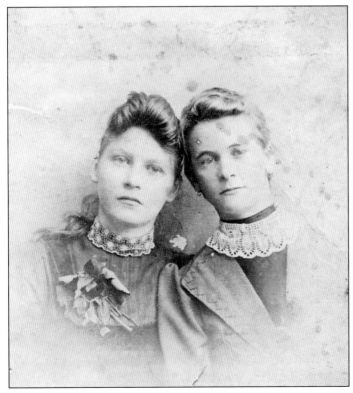

Ella Everett (left) and Dora Russell were not only first cousins but also best friends. They grew up in the Union community. Dora Russell died at the age of 17. Later Ella married Theodore Montgomery and became the mother of Louise Montgomery. (Courtesy of Paul Russell Swan.)

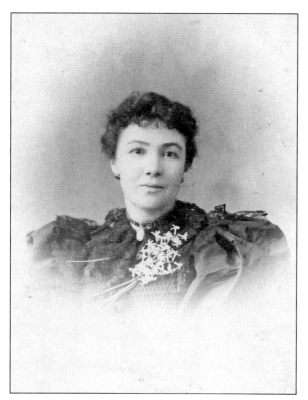

Lillian Campbell was reared in the Union community with the Everett and Russell families. She was a sister to John A. Duncan, an attorney at Concord. This photograph was probably taken in the late 1890s. (Courtesy of Paul Russell Swan.)

Susan Pitts of North Campbell Station Road in Hardin Valley is pictured with Walter Gordon Woods, her mail carrier for 47 years. After his retirement, he often stopped by to chat with former patrons. Pitts is standing under the tree that shaded her spring. It was this place that Woods chose for a rest stop in the early days with his horse and buggy. (Courtesy of James Welch Woods.)

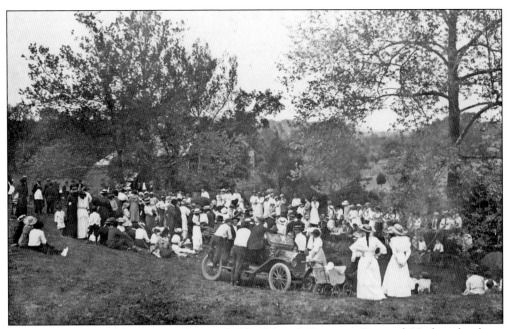

An emancipation celebration in 1914 was held at Vance's Spring in Concord. Nothing has been found about the programming, but there were probably several speakers. Both white and black communities attended. (Photograph by Henry F. Smith; courtesy of Barbara Beeler.)

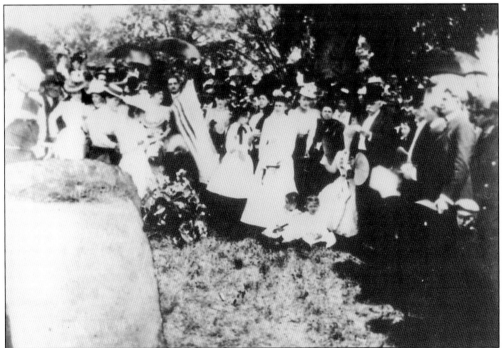

The Bonny Kate Chapter, Daughters of the American Revolution, erected a monument in 1902 to honor Adm. David Glasgow Farragut. Adm. George Dewey was present to dedicate the monument placed on the site of Admiral Farragut's birthplace at Low's Ferry. (Courtesy of Farragut Folklife Museum Collection.)

Concord's Dr. Malcolm Freels Cobb and his wife, Bessie Lloyd Cobb, enjoy an evening out, which was an infrequent occasion for the busy doctor. They were probably attending an event at Deane Hill Country Club, where most large group functions were held. (Courtesy of Julia Cobb-Freer.)

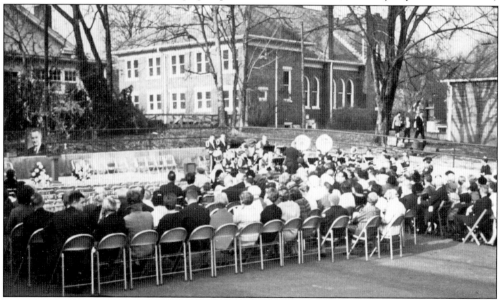

In 1967, the Concord–Campbell Station communities gathered at Concord to dedicate the new post office. The population of the area had increased, and the Olive Road building was no longer adequate. Sharp's Store and the covered boardwalk were razed to make way for the new building to be attached to the stone store. In just a few years, this building too could not meet the rapid growth of the area. The heaviest population, now in the Farragut area, required a larger facility to be built there, leaving Concord in 1981 after a century of service. (Courtesy of Harlan Frederick Dunlap.)

The sign announcing "Tennessee Homecoming '86" was small in comparison with the large impact on the newly incorporated town of Farragut. When Dinah Shore, popular entertainer of radio, television, and movies, accepted an invitation to return to her hometown of Winchester, Tennessee, for a homecoming, she promoted the event on her programs. Gov. Lamar Alexander proclaimed the state to have a Tennessee homecoming in the summer of 1986 with heritage and other programs to encourage and draw people back home. Farragut's heritage program was a summer museum that became permanent in 1987. These signs were placed along the roadways in Farragut. (Courtesy of Farragut Folklife Museum Collection.)

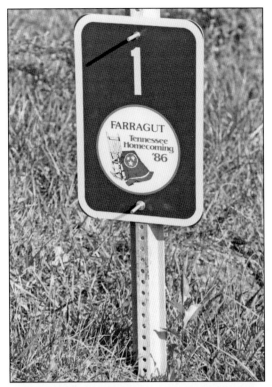

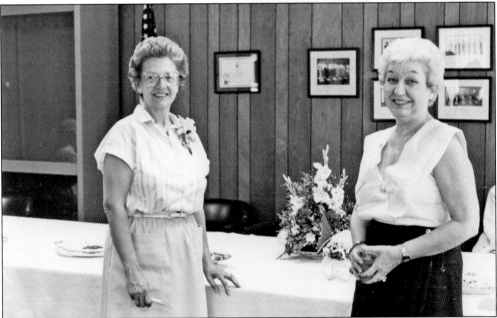

Mary Nell McFee (right) is shown with author Doris Woods Owens as the Farragut Folklife museum hosts a reception and open house in 1989. McFee organized the town of Farragut's first museum in 1987 and served as its curator until 1992. Owens was appointed director and served through 2007. These were the only two who served as volunteer curator and director since the museum's inception. (Courtesy of Farragut Folklife Museum Collection.)

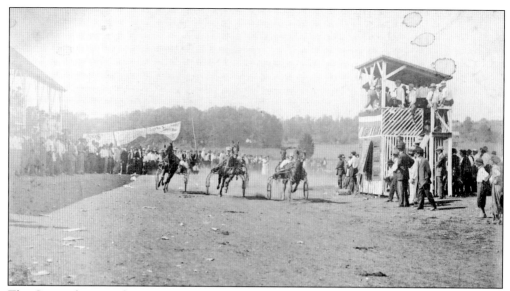

The Concord racetrack was a part of the Concord Fair, held annually from 1895 to 1918. The track was on the east side of Concord Road on what was later known as Elmer Henry's farm. It would cover the present subdivision of Farragut Farms and reach on the back side to Loop Road. It brought in the finest horses from many states for the races. Various competitions in light harness, trotters, and riding events for both men and women were featured. Many other contests were offered in the midway, where booths and rides were set up for children. (Photograph by Henry F. Smith; courtesy of Barbara Hall Beeler.)

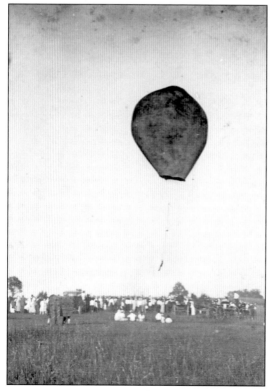

A smoke balloon demonstration captured the crowd's attention at the Concord Fairgrounds in the early 1900s. Unlike the hot air balloons of today, the smoke balloon had no basket for a rider. The demonstration in progress appeared to take the rider to unknown heights. Actually, the balloon was tethered securely, so there was little chance of balloon and rider disappearing into the clouds. (Photograph by Henry F. Smith; courtesy of Barbara Hall Beeler.)

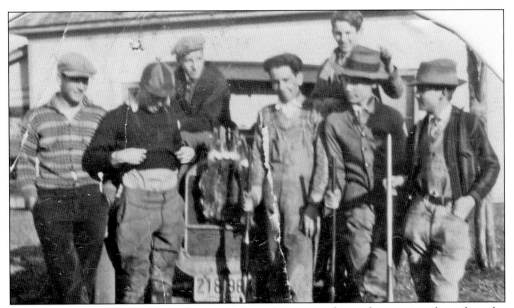

Hunting was a popular sport in the area. Not only was it a form of recreation, but often the game served as food for the family. Game was plentiful in the area of large farms. Ready for the hunt, friends here are gathered in the early 1930s at the Charles Watt farm on old Stage Road. (Courtesy of Bob Watt.)

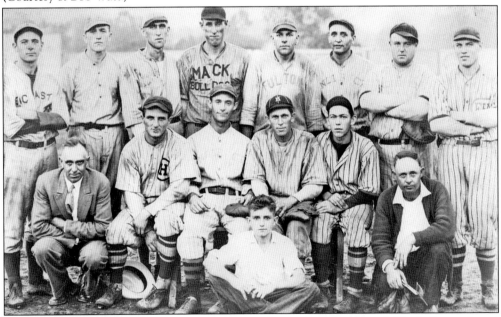

The Concord adult baseball team brought out crowds wherever they played. The ladies made and sold lemonade to the hot spectators at the games. This particular team was often referred to as the "Unbeatables." Pictured from left to right are (first row) batboy Howard Hammond; (second row) S. H. Hammond, manager; M. L. "Jake" Russell Jr.; Charles Boring; brothers W. A. "Pat" and Claude Donovan; and John Smith; (third row) Horace McCammon; Robert "Bob" Woods; Dennis Donovan; Jeff Oliver; Walt Woods; two unidentified; and Roy E. Graham. (Courtesy of Hannah Michelle Mills.)

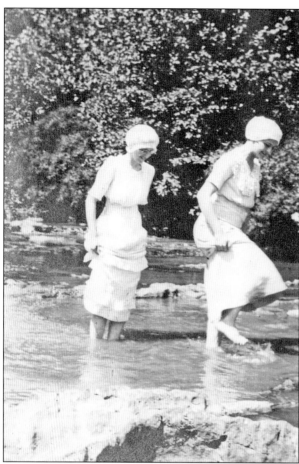

There is nothing more refreshing in the hot summertime than to take time to wade in the cool waters of Turkey Creek. In 1914, the young ladies found just the right spot for wading behind Hackney mill. They are unidentified. (Courtesy of Gene McNutt Abel.)

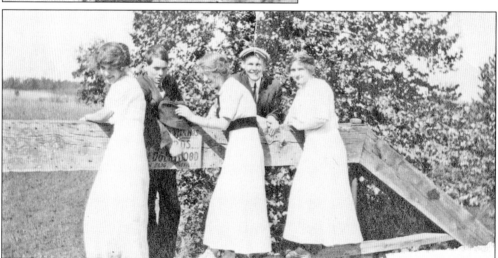

Friends gather on the weekend to enjoy the warm day. There is always a camera available at these outings. The young people referred to these times as "going kodaking." Friends shown hanging on the bridge are, from left to right, Edna Winfrey, Milford Hertzler, Dean Galbraith, Bill Woods, and Hallie Hackney. (Courtesy of Byron and Gaines Harmon.)

Four

FAMILIES

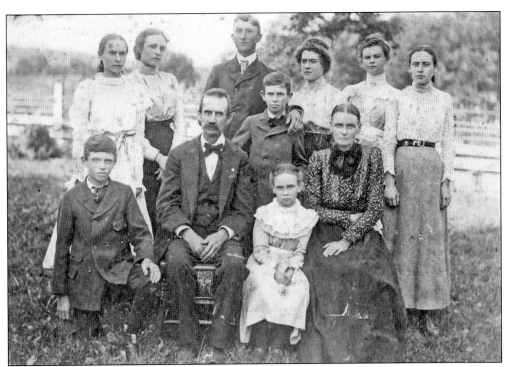

Edward Moore Campbell and his second wife, Nancy Elizabeth Bell Campbell, are shown in the early 1900s with their nine children. They are, from left to right, (first row) Oscar Alexander, father Edward Moore, Edward Russell (standing behind his parents), Esther Lynn (seated in front), and mother Nancy Elizabeth; (second row) Jeanette Houston, Martha, William Arthur, Josephine, Ella Mae, and Anna Cordelia. (Courtesy of John Steele Campbell II and Neta Lynn Campbell Lawhorn.)

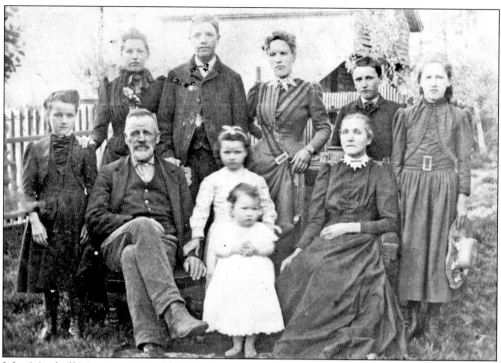

John Marshall Montgomery and his wife, Mary Jane Wilkerson, are shown about 1900 with their eight children. Ida Lee, William Austin, and Hattie were born before the family settled in Virtue in 1870. Five more—John Chester, Mary Anna, Martha Elizabeth, Dorothy Evelyn, and Rella Jane—were born there. (Courtesy of Julia M. Scott and Tucker Montgomery.)

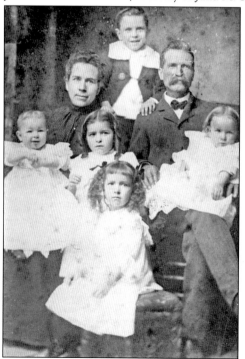

The Doctor Crockett "D. C." Kincer family moved to Concord, Tennessee, from Wythe County, Virginia, in 1902. Michael Gordon "M. G." (not pictured), a son from D. C.'s first marriage, moved with his father. They bought adjoining farms on Low's Ferry Road, now known as Northshore Drive. D. C. and his second wife, Mary Ellen, had four children before leaving Virginia, and their fifth was born in Tennessee. Pictured with their parents are, from left to right, (first row) Mary Agnes, born 1898; (second row) Emma Crockett, born 1903; Bertha Gladys, born 1899; and Annie Margaret, born 1901; (third row) Mary Ellen and D. C. Kincer; (fourth row) McKinley, born 1897. (Courtesy of Farragut Folklife Museum Collection.)

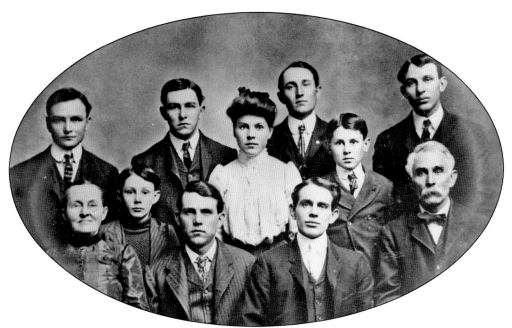

Joseph Albert Boring moved his family to Knox County from Blount County in 1873. He settled on a large farm west of Campbell Station Inn, where he and his second wife, Ellen Fleming Grigsby, reared nine children. Family members are, from left to right, (first row) Ellen, Nathaniel, Robert, and Joseph Albert; (second row) Charles, Annie, and John; (third row) Joseph, William, Fleming, and Frank. At least five of the Boring children attended the new Farragut High School. Joseph Jr. and William were on the school's first football team in 1905. (Courtesy of Julia "Judy" Boring Solomon.)

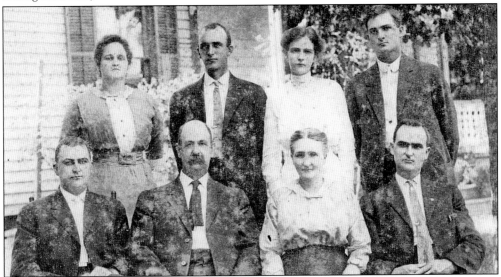

The John Miller family gathers at the family home in Concord about 1915. The house, which had been remodeled, was the former private school run by the Russell sisters on the east side of Olive Road at the crest of the hill. From left to right are (seated) Ernest, John, Elizabeth "Betty", and Horace; (standing) Stella, Hubert, Lula, and Elliott. (Courtesy of Farragut Folklife Museum Collection.)

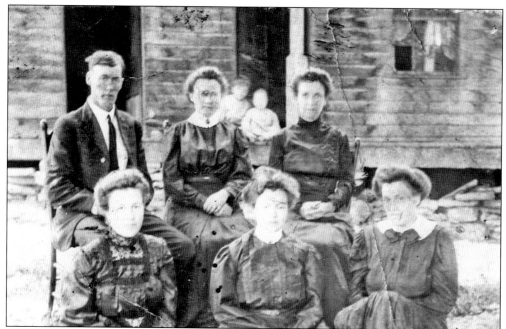

Henry Franklin Smith, born at Concord in 1875, is pictured in 1900 with his five sisters: from left to right, (first row) Nancy (Taylor), 32; Dolly (Johnson), 19; and Stella (Spangler), 21; (second row) Henry, 25; Sally (Thomas), 27; and Lucy (Laughlin), 29. Henry and his sisters had another reunion in 1935, again recording it with a picture. (Courtesy of Barbara Hall Beeler.)

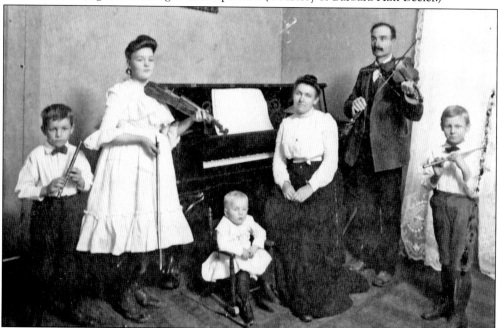

Members of the James Farmer Woods Jr. and Emma Seaton Woods family are ready to make music. J. F. not only played the violin, but he also taught his children and others in the community. The family also sang together. The children are, from left to right, Walter Gordon, Martha Irene, Robert Lee (seated), and James William. (Courtesy of Kenneth Seaton Woods.)

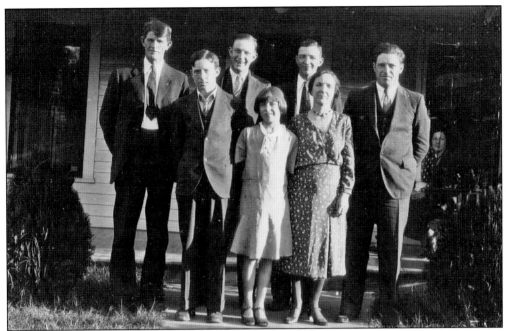

The family of William Henry and Adra Wheeler Raby is pictured here in the 1930s at the family home on the corner of Herron and Campbell Station Roads. They are, from left to right, (first row) Wayne, Grace, and Adra; (second row) William Henry, Nelson, John, and Clifton. Early deeds showed that the Raby families occupied farms in the Campbell Station area. Over the years, members of the family served on the utilities and town boards, as a continuous volunteer for the election commission, and as a law enforcement officer. (Courtesy of Carolyn Coker.)

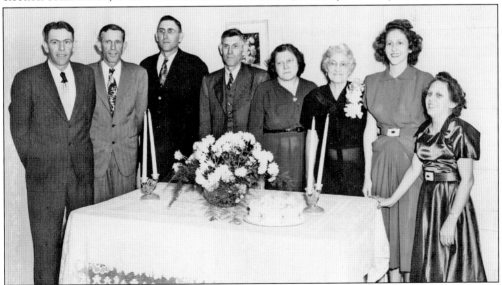

Molly Fox Donovan, born in 1877, is pictured with her seven children in the 1940s. Her husband, Dennis, died in 1928. She was a talented seamstress and relied on that skill for her income. Pictured here are, from left to right, Claude, W. A. "Pat", Dennis Jr., Joe Michael, Anna Leuscile, Molly, Dorothy, and Edith Merrill. The four sons were in road building and maintenance. (Courtesy of Wilma "Billie" Donovan Benson.)

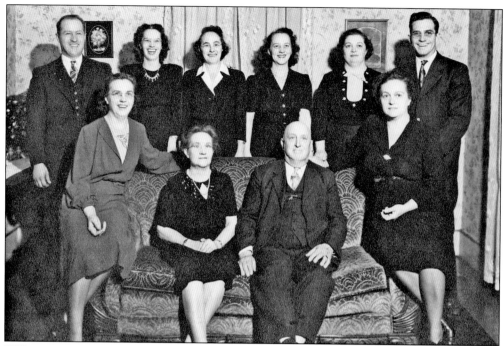

William McCamey Fox, born 1877, and Lou Mae Koon, born 1879, are pictured with their eight children in the mid-1940s. From left to right are (first row) Naomi Donovan, Lou and W. M. Fox, and Edith Brashier; (second row) William McCamey Jr., Ruby Hobbs, Mabel Vance, Mildred Benson, Anna Louise Harley, and David Nelson Fox. (Courtesy of Charles Warren and Billie Donovan Benson.)

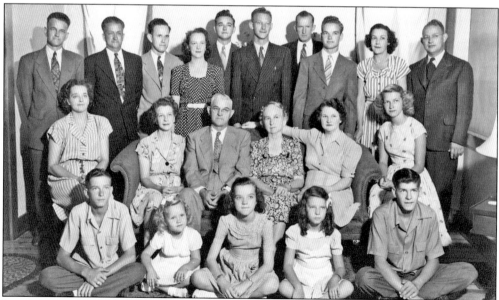

Jesse Mack and Lillian (Hays) Benson of Concord are shown in the mid-1940s with their six children, their children's five spouses, and eight grandchildren. Jesse was a machinist, inventor, entrepreneur, and founder of the Benson Winch Company, which produced winches for the government during World War II. (Courtesy of Charles Warren Benson.)

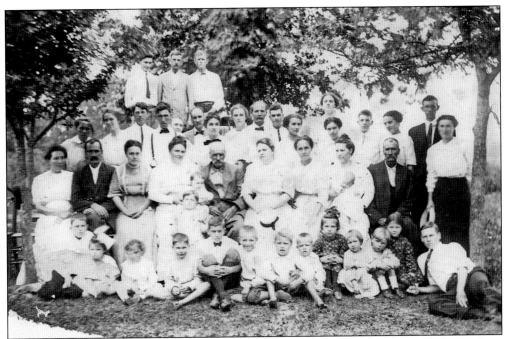

The J. F. Woods Sr. family reunion was held at the home of John and Mary Campbell Woods on Evans Road in the summer of 1913. J. F. was married twice, first to Martha McQueen of Georgia. They had seven children, five of whom made it to adulthood and attended the reunion. He and his second wife, Lizzie Hamblen, had eight children, with at least six attending this event. Family names represented were Hobbs, Barnhill, Martin, Winfrey, Davis, Johnson, and Hyden. (Courtesy of Kenneth Season Woods.)

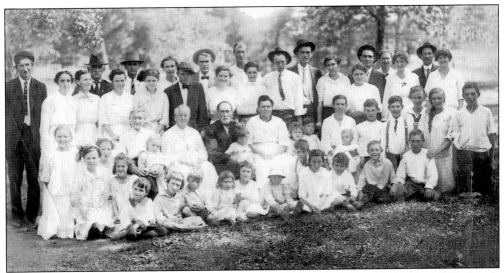

This is the family reunion of Joseph and Rebecca Lucy Smith of Concord held in 1915. Family names represented are Taylor, Johnson, Spangler, Thomas, Laughlin, and Starkey. The event was probably held at Vance's Spring, where local gatherings were often held. The Lucy family lived in Possum Valley in the Harvey Road area. (Courtesy of Barbara Hall Beeler.)

Four generations of the DeBusk-Harvey family are shown about 1919. They are, from left to right, (first row) Elisha DeBusk, Eddie Sypress Harvey, and Isabel Huff Debusk; (second row) Jennie Isabel DeBusk Harvey and her father, Addie N. DeBusk. The DeBusk family settled in Greene County, Tennessee, before 1830. Elisha was the 11th of 14 children born to Elijah and Molly Wren DeBusk. (Courtesy of Jennie Roberta Harvey Jones.)

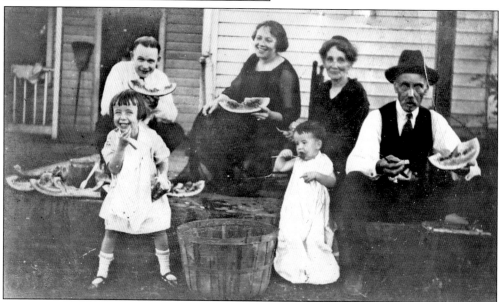

A watermelon feast on the cistern top of the McNutt home in Concord was held about 1923. Pictured from left to right are (first row) Anne Mary and "Mackie" Abel; (second row) Madison McNutt, Jean McNutt Abel, Annie Cox McNutt, and Sandy A. McNutt. (Courtesy of Gene McNutt Abel.)

Elizabeth Rodgers, better known as Lizzie, was born October 28, 1866. She was the sister of Sam Rodgers, whose farm was located on the north side of Kingston Pike near Sherlake Lane, west of the present Windsor Square. Lizzie married Albert Addison Woods in the early 1880s, and they were the parents of Roy, Mabel, Alma, and Lydia. Lizzie died in 1898 at the age of 31 and was buried in Concord Masonic Cemetery. She was the great-grandmother of Linda Laughlin Ford. (Courtesy of Linda Laughlin Ford.)

The adult children of Albert Addison Woods and his first wife, Lizzie Rodgers, are, from left to right, (seated) Lydia Woods Davenport; (standing) Alma Woods Singleton, Roy Woods, and Mabel Woods Hobbs. Mabel and Fred Hobbs were the grandparents of Linda Laughlin Ford, who became Farragut's first lady when her husband, Eddy, became the town's second mayor. (Courtesy of Linda Laughlin Ford.)

Nothing can be more romantic than buggy riding with your best beau on a Sunday afternoon. John Boring took Clara Russell for many rides. They later married and reared a family of three daughters and one son, all productive members of the community. (Courtesy of Judy Boring Solomon.)

Sarah Emaline Campbell was the daughter of James and Sarah Smith Campbell. Her father willed her 114 acres of land in Loudon County. On February 17, 1858, she married Robert Tate Gound. They had 11 children. She is pictured in front of the "Elder" David Campbell log house, built in 1810 by her Revolutionary War ancestor. (Courtesy of Neta Campbell Lawhorn.)

Ella Campbell, daughter of Edward Moore Campbell, is shown in the early 1900s. Over the years, Ella was married five times. She was very elegant and refined and truly a lady. (Courtesy of John Steele Campbell II.)

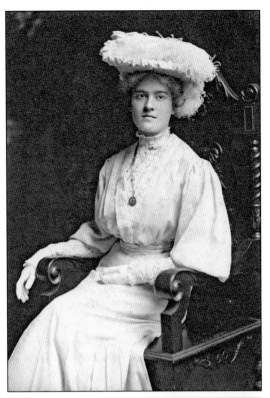

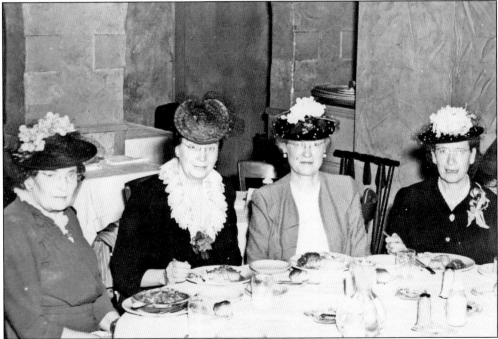

The four daughters of Edward Moore Campbell meet for dinner in Washington, D.C., sometime in the late 1930s or early 1940s. From left to right are Josephine, Martha, Ella, and Anna. (Courtesy of John Steele Campbell II.)

Lizzie Love Russell, one of three daughters of Samuel Love and Amanda Rodgers Russell, is shown celebrating her 95th birthday. Alice, the oldest of the three sisters, was director and teacher of their private school, and Jean was a devoted Sunday school teacher and church worker, but Lizzie was a homebody and enjoyed keeping house for the others. The sisters never married. When Jean and Lizzie were in their 70s and Alice had been dead several years, the house became too large for Lizzie's care. They moved to Anniston, Alabama, to be with relatives. (Courtesy of Linda Laughlin Ford.)

The Russell-Rodgers family reunion was held at the home of Samuel and Amanda Rodgers Russell on Olive Road in Concord. The house is currently owned by Gene McNutt Abel, a relative who has continued to host the reunions. (Courtesy of Linda Laughlin Ford.)

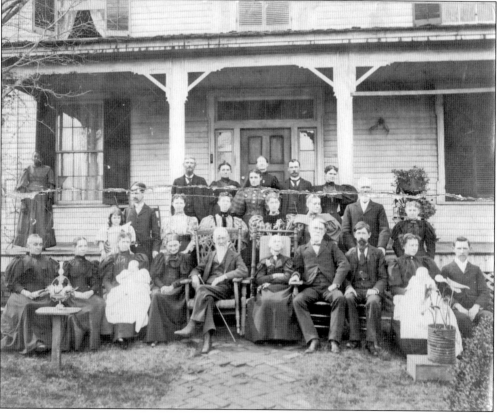

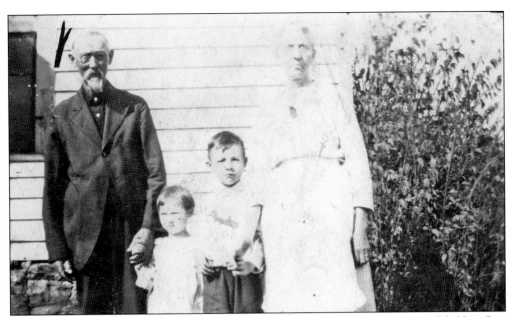

George Pinkney Hobbs and Martha Tennessee Hobbs are pictured with their grandchildren Ray and Ruth Hobbs, whose parents were Fred and Mabel Hobbs. The Pinkney Hobbs house was at the northeast corner of South Loop and Concord Roads. Later it was known as the Clarence "Queenie" Hobbs house. (Courtesy of Linda Laughlin Ford.)

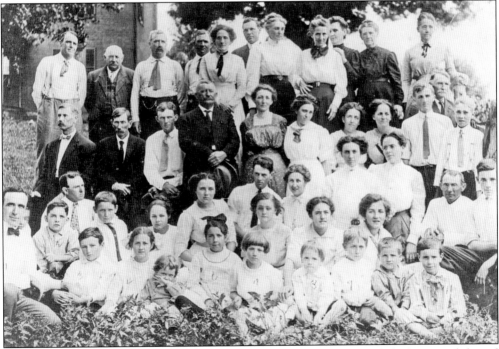

The Russell brothers—Charles (first row, far left), Avery (third row, left, facing right), and Matthew (fifth row, third from left)—gather for a reunion with their families and a few friends about 1910. In Campbell Station, Avery and Charles had dairies and Matthew operated a grocery store, carrying on a long family tradition. (Courtesy of J. Frank Russell Jr.)

Henry Franklin Smith and Margaret Rodgers Smith are shown in 1946 with their children, spouses, and grandchildren. From left to right are (first row) Billy and Frank Hall; (second row) Lillian and Kathern Dailey; Henry, Margaret, and Augustus Vannes "Gus" Smith; and Barbara Hall; (third row) William Dailey, Helen Smith (Arthur's wife), Helen Smith Hall, Arthur Smith, Mary Margaret Smith, and William "Bill" Hall. (Courtesy of Barbara Hall Beeler.)

Three generations of the Harvey family are James Robert Harvey, his father, Oney Sypress Harvey Jr., and Oney's grandson Addie Sypress Harvey. The Harveys came to the area in the early 1800s. The picture was taken at the Oney Harvey house. The design in the sheer window panels indicates the style in the late 1910s and early 1920s. (Courtesy of Jennie Roberta Harvey Jones.)

Five

A CENTURY OF WEDDINGS

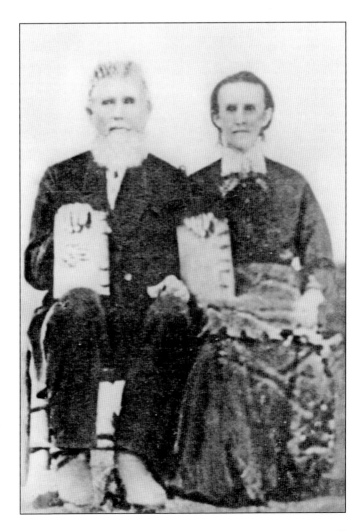

This 1860 photograph was taken at the wedding of John Steele Campbell and his second wife, Elizabeth Jane Henry. The couple lived in the old log house on Harvey Road that was built by "Elder" David Campbell, a Revolutionary War soldier and cofounder of Campbell Station. (Courtesy of John Steele Campbell II.)

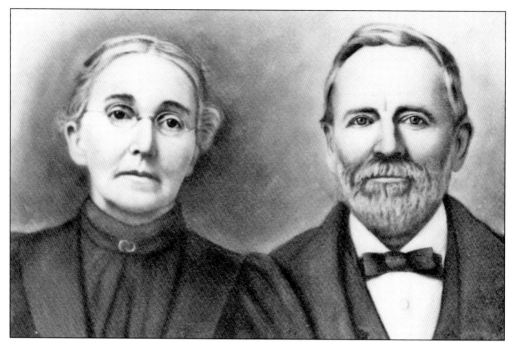

John Marshall Montgomery and Mary Jane Wilkerson were married on November 28, 1867. About 1873, they settled on a large farm in the Virtue community, where they reared their eight children. John donated the land for a church and cemetery named Prospect Church and later named Virtue Cumberland Presbyterian Church. (Courtesy of David and Alicia Galbraith.)

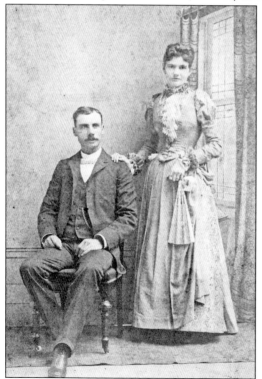

It is thought that this is the wedding photograph of Lizzie Rodgers and Albert Addison Woods. According to a letter written in 1887 to his brother James F. Woods Jr., Albert invited James and his wife, Emma, to visit while they were living in Knoxville. By the 1890s, both families had settled in Concord. (Courtesy of Linda Laughlin Ford.)

James Farmer Woods Jr. and Emma A. Seaton were married on July 19, 1886, at the home of the bride's father, James Nelson Seaton of Cedar Bluff. Their courtship and marriage are well documented in the family Bible and in letters Emma kept. (Courtesy of Rufus Gaines Harmon.)

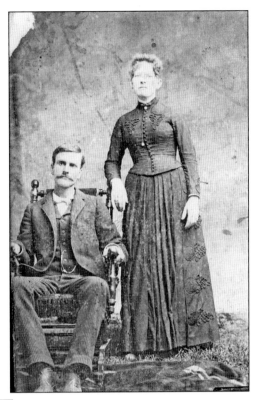

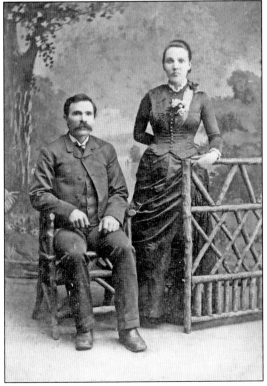

Matthew Gaston Galbraith married Ida Lee Montgomery in 1888. They made their home on the east side of Turkey Creek, where they reared four children: Floyd, Roy, A. D. "Abe", and Gladys. In 1917, Matthew had a large, attractive home built, replacing the 1870 house. (Courtesy of David and Alicia Galbraith.)

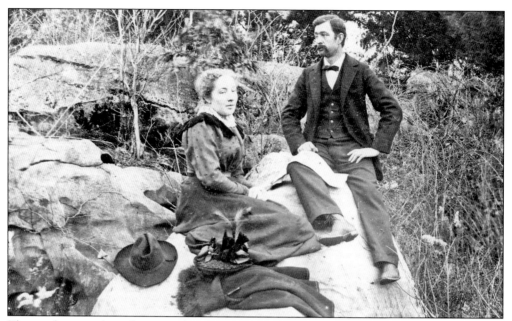

This newly married couple, pictured in the 1890s, is John L. Woods and Sallie McCluren Campbell of Concord. John was the youngest son of James Farmer Woods Sr. and Martha Ann McQueen. Like his father and his two brothers, John was a stonecutter and mason. Sallie was the first of three children born to Edward Moore Campbell and Jeanette Pepper Campbell. (Courtesy of John Steele Campbell II.)

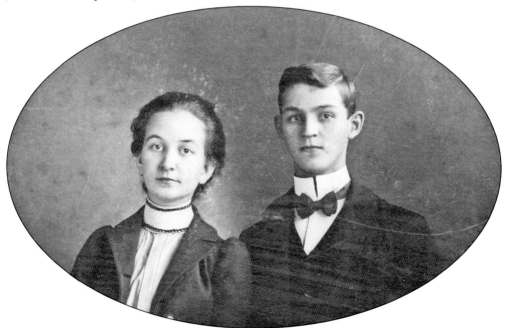

Jesse Mack Benson and Lillian Ann Hayes were married in 1900. They reared six children, four sons and two daughters. Jesse was an inventor who tried to invent things to benefit the community, such as the deep well pump. During World War II, he had a government contract to build hoisting machines used to lift and lower anchors on ships. (Courtesy of Charles Warren Benson.)

Margaret Elizabeth Rodgers of Graveston, Tennessee, is shown in her wedding finery. In 1900, she married Henry Franklin Smith, a young baseball player from Concord. (Courtesy of Barbara Hall Beeler.)

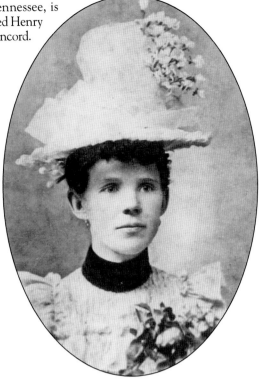

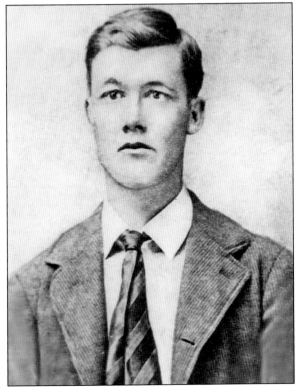

Henry Franklin Smith, a stonecutter, met Margaret Elizabeth Rodgers of Graveston while playing on a baseball team with other stonecutters. After their marriage in 1900, they lived in Graveston five years before returning to Concord. (Courtesy of Barbara Hall Beeler.)

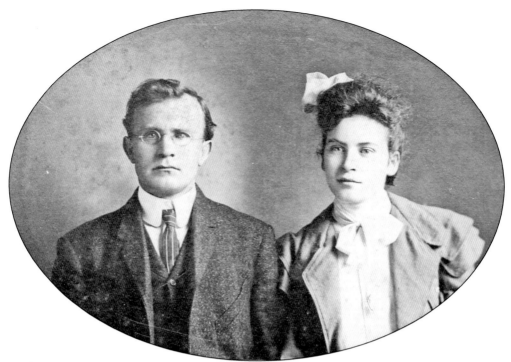

Andrew Lamar and Anna Cordelia Campbell are shown in their wedding picture in 1903. Both Andrew and Anna were descendants of "Elder" David Campbell, a Revolutionary War soldier and cofounder of Campbell Station. About 1918, Andrew built a large farmhouse near the 1810 log home built by "Elder" David. Andrew's son, John Steele Campbell II, lives there currently. (Courtesy of John Steele Campbell II.)

The newlyweds of Concord seem to be enjoying the ride in this 1918 photograph. In the front are Rev. Rufus Gaines Reynolds and bride Irene Woods Reynolds. The happy couple in the back is Charles and Mame Johnson Thompson. Irene and Mame are cousins. (Courtesy of Rufus Gaines Harmon.)

Jennie Isabell DeBusk, daughter of Addie S. DeBusk of Knoxville, and James Robert Harvey, son of Oney Sypress and Martha Bright Harvey of Concord, were married on September 7, 1915, in the First United Brethren Church of Knoxville. James was a merchant working for Commonwealth Company selling hats and caps. He also grew boxwood shrubbery to sell, and Jennie took on her long-lasting role as housewife and mother. The couple moved into the old Boyd house on Harvey Road, where they reared their six children. (Both courtesy of Jennie Roberta Harvey Jones.)

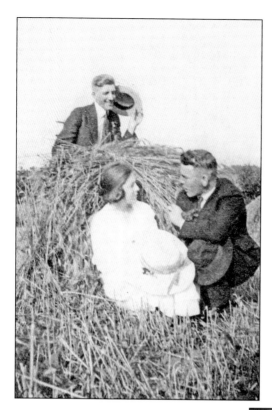

This picture of Ziza Welch and Walter Woods was probably made a few days before their wedding. They married on July 30, 1920, the first couple to marry in the new Concord Methodist Church. Walter's brother-in-law Rev. Rufus Gaines Reynolds officiated. The friend appearing over the haystack is unidentified, although he could have been the one who hid their car when it was time to leave on their honeymoon. (Courtesy of James Welch Woods.)

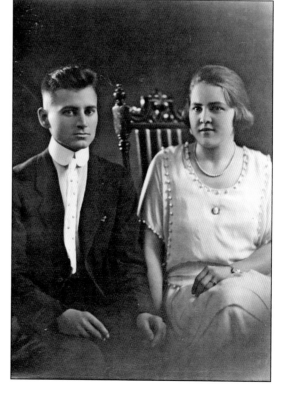

At the wedding of Lula Virginia Kincer and Roscoe Conklin Irwin on July 20, 1921, at Concord Methodist Church, it was the groom who was left standing at the altar, but not for long. On the way to the church in the rain, the Kincers' new car became stuck in the mud, delaying them a short time. The bride's dress was made by her mother with the exception of 198 acorn-shaped buttons used in the trim, which became Lula's job. (Courtesy of Carolyn Irwin North.)

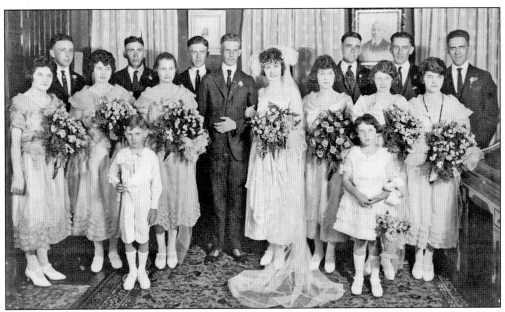

The wedding party of 1916 Farragut High School graduate Hazel Deane Koon and Charles William Turner is shown following their marriage on June 16, 1921, at Graystone Presbyterian Church in Knoxville. Hazel had other Farragut graduates as her attendants. Her sister Ruby Koon (1915) was maid of honor, followed by Goldia Henson (1916), Hazel's classmate. Other bridal attendants were Iva Price (1915), Ruth Turner, Aileen and Rosalie Edmundson, and flower girl Dorothy Stone. (Courtesy of Doris Woods Owens.)

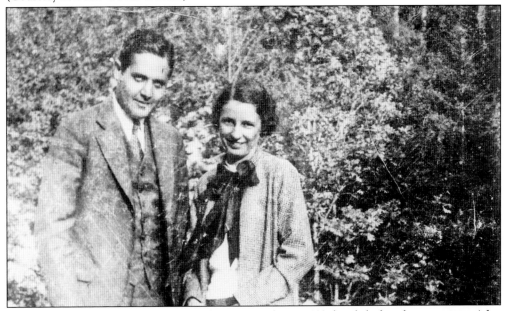

Dr. John Lee Montgomery is pictured with Agnes Tucker in 1933 shortly before their marriage. After finishing medical school at Memphis and completing a year of residency, Dr. Montgomery began his medical career as a general practitioner in Erwin, Tennessee, where he met Agnes. Soon after their marriage on February 11, 1934, they moved to New Orleans, where Dr. Montgomery completed an eye, ear, nose, and throat residency at Charily Hospital. (Courtesy of Tucker Montgomery.)

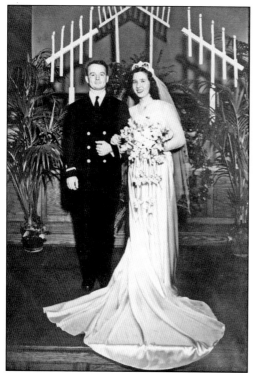

Gene McNutt Abel and Frances Priscilla Larson were married on May 12, 1944, at Little Brook Presbyterian Church in Knoxville. The Reverend Bertram Maxwell Larson officiated at the marriage of his daughter. World War II had interrupted their wedding plans, but as soon as Abel completed officer's training and achieved the rank of ensign, he received a three-day pass. They wasted no time and proceeded with the wedding. After the war, they made their home in Concord, where both were active in their church and community life. (Courtesy of Gene McNutt Abel.)

The Harvey sisters, Jennie Roberta (left) and Frances Geneva, planned their wedding together. It was the first if not the only formal double wedding in Concord. The couples were married in 1946 at Crichton Memorial Baptist Church with Rev. Udell Smith performing the ceremony. From left to right are Jennie Roberta with Gilbert Guy Jones Jr. and Frances Geneva with Oliver Newman. (Courtesy of Jennie Roberta Jones.)

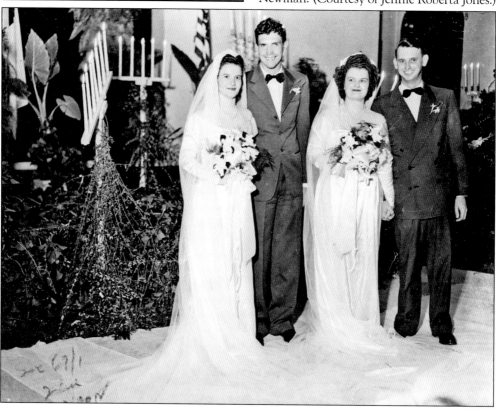

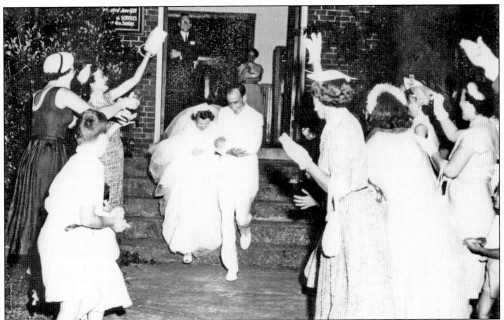

Bill and Katherine Dunlap were photographed leaving Concord Methodist Church following their wedding ceremony in 1954. Bill graduated from Rhode Island School of Design. He retired from Oak Ridge National Laboratories, where he was an interior designer. After retirement, Dunlap helped to establish Farragut Folklife Museum and served as its volunteer exhibits designer for 20 years. Katherine was a high school English teacher. She taught piano and also volunteered for many years as pianist for Grigsby Chapel, one of the small churches in the Farragut area. (Courtesy of Bill Samuel Dunlap.)

John Steele Campbell II and Elsie Longmire Campbell pose for this picture soon after their marriage in 1959. The couple made their home on the farm where John's great-grandfather, "Elder" David Campbell, lived after the Revolutionary War. The original house was built of logs and it served two generations, but John's father, Andrew Lamar, replaced it with a large farmhouse. (Courtesy of John Steele Campbell II.)

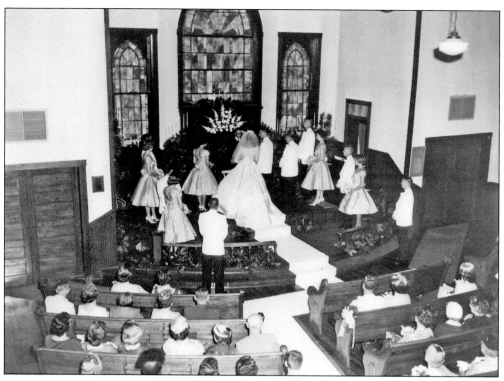

This was one time when having your back to the camera was not a bad thing. This rather unusual view of the wedding party was taken from the balcony of Concord Methodist Church as Linda Laughlin and Walter Edward Ford III repeated their marriage vows in 1960. From all accounts, this romance blossomed in early elementary school. Who would have ever dreamed that 33 years after this picture, he would have become mayor and she first lady in a town called Farragut? (Courtesy of Linda Laughlin Ford.)

Author Doris Owens's grandmothers are shown at the lawn reception following Doris's wedding to Charles S. Owens on June 18, 1949. Viola Rogers Welch (left), maternal grandmother, and Emma Seaton Woods, paternal grandmother, traveled from Knoxville for the ceremony and reception. (Courtesy of Byron and Gaines Harmon.)

Six

CHILDREN

"Admiral Billy Samuel Dunlap at the helm of his first vessel" was a title suggested for this picture by his brother Chester. Bill was a 20-year volunteer in Farragut's Unsung Navy. Volunteers earned their ranks by the number of hours they served. Bill, the former exhibits designer for Farragut Folklife Museum, earned well over the required number of hours to be an admiral. In a recent parade, "Admiral Dunlap" cruised down Kingston Pike at the wheel of the USS *Hartford*. (Courtesy of Harlan Frederick Dunlap.)

The infant ready for his christening is Neal Campbell, the son of William and Blanche Smith Campbell and great-grandson of the Revolutionary War soldier "Elder" David Campbell. His grandparents were Edward Moore and Nancy Elizabeth Bell Campbell. Christening was always a time for family members to come together. (Courtesy of John Steele Campbell II.)

Martha Irene Woods, the one-year-old daughter of James Farmer Jr. and Emma Seaton Woods, was the second of six children born to the young couple. The family was living in the Cedar Bluff community at the time of her birth but moved to Concord soon after. (Courtesy of Byron and Gaines Harmon.)

Mary Margaret Smith's picture was taken by her father on her first birthday. She was the daughter of Henry Franklin and Margaret Elizabeth Rodgers Smith of Concord. During World War II, Margaret's patriotism was obvious when she joined the Women's Auxiliary Army Corp (WACs). She returned to Concord after retirement. (Courtesy of Barbara Hall Beeler.)

An unidentified woman is pictured soon after delivering triplets with the help of Dr. Malcolm F. Cobb of Concord. Her three older daughters get their first look at the three tiny, but apparently quite healthy, babies. This home delivery appears to be in the early 1940s. (Courtesy of Julia Cobb-Freer.)

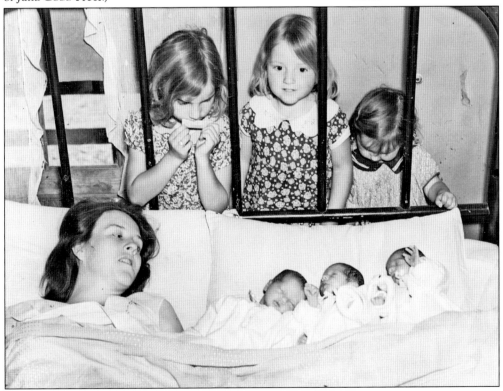

John Jewell North was born in Birmingham, Alabama, in 1932 but came to Knox County at an early age. He attended Farragut High School and married his high school sweetheart, Carolyn Irwin. Both were volunteers at Farragut Folklife Museum for many years. (Courtesy of Carolyn Irwin North.)

The Reynolds sisters appear to be at ease as they pose for this August 1923 picture. Martha Gaines (left) and Emma Frances were the daughters of Rev. Rufus Gaines and Irene Woods Reynolds of Concord. Martha Gaines was given the nickname "Tut" by her father. It was used throughout her life by all family members except her mother. (Courtesy of Rufus Gaines Harmon.)

The children were told not to move or the picture would not be good, which accounts for such solemn expressions; the proud parents were Jesse Mack and Lillian Hays Benson of Concord. The children are, standing from left to right, Hazel, Mary, and Charles Thomas. Seated is baby Howard. (Courtesy of Charles Warren Benson.)

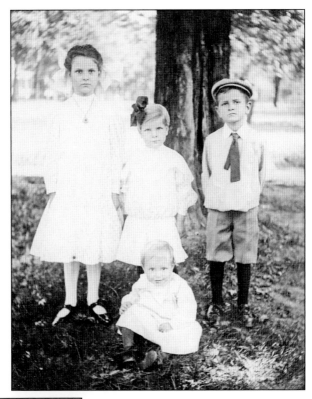

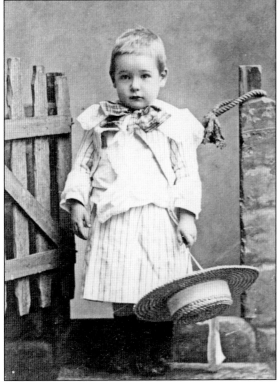

Moses Madison McNutt, as a not very happy little boy, wears an outfit that is currently on display at the Farragut Folklife Museum. The boy was named for his grandfathers, Moses White McNutt and Dr. Henry Madison Cox. His Concord nickname was "Duckie." Little Madison was born about 1897 and was three years old when this picture was made. It was a custom at that time to dress little boys in dresses similar to girls until the age of five. This custom probably accounts for Madison's expression. (Courtesy of Gene McNutt Abel.)

Gabriel Winston Holder is photographed with his grandchildren Clarence Miller, age three, and Freddie Lucille Miller, about six years old, in 1903. Clarence and his wife, Amanda Bennett, both attended Virtue School. They were the parents of one daughter, Mary Alice. Freddie married Harlan Richard Dunlap and had three children, Chester, Bill, and Norma Elaine. (Courtesy of Bill Samuel Dunlap.)

The three youngest children of William Rufus and Harriett Emma Jones Dunlap are, from left to right, Charles Glenn, Nancy Eunice, and Dorothy Mae. They had four older siblings. Their father died in 1904, the year Eunice was born. Their mother relocated from their farm at Chota to Virtue and eventually to Concord. (Courtesy of Bill Samuel Dunlap.)

The sons of Matthew Gaston and Ida Montgomery Galbraith shown here are Floyd (left), Roy, and A. D. "Abe" (seated in front). They were reared on a farm bordering Turkey Creek in the Virtue community. As young men, Roy and A. D. operated buses running between Lenoir City and Knoxville. Floyd remained on the farm. A. D. was later called on by many of the community who had need of his skills as an electrician. (Courtesy of David and Alicia Galbraith.)

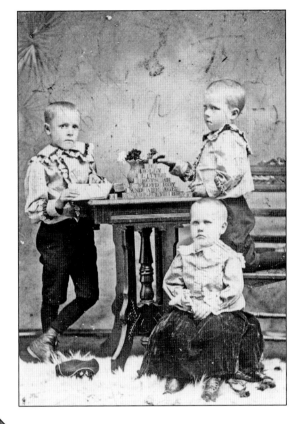

Gladys Galbraith was two years old when this photograph was made in 1910. She was the youngest child and only daughter of Matthew Gaston and Ida Montgomery Galbraith. Gladys attended Farragut High School, graduating in 1925. At some time, she was stricken with rheumatoid arthritis, and the last years of her young life were spent confined to her bed or a wheelchair. Gladys died on December 21, 1945, at the age of 37. (Courtesy of Elbert Hale Heft.)

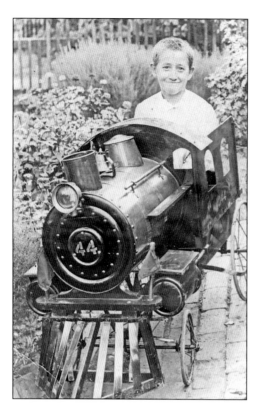

Charles Boyd Fritts, the 10-year-old engineer on the throttle of the locomotive, is ready for his regular run to the many places in his make-believe world. After his career as an engineer was over, Fritz lived in the Lovell community with his children, Lee "Buddy" and Doris. (Courtesy of Lee Fritts.)

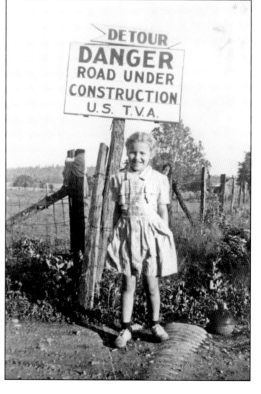

Carolyn Leota Irwin, the youngest daughter of Roscoe Conklin and Lula Virginia Kincer Irwin, is shown in 1941 standing beneath a "sign of progress" in front of her Concord home. It would soon be hanging over the heads of other Concord families who would be forced to move with the completion of Fort Loudoun Dam. (Courtesy of Carolyn Irwin North.)

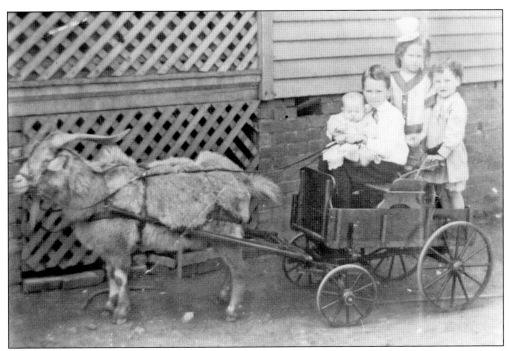

Ready for their ride in the goat cart about 1910, the children are, from left to right, Clifford Watt being held by Charles Watt, Eula Watt (who married Glen Everett), and Alford Watt. Eula taught school at Farragut for many years. (Courtesy of Bob Watt.)

Emma Frances Reynolds gladly poses in her favorite outfit for this 1922 picture. She was the first of two daughters born to Rev. Rufus Gaines and Irene Woods Reynolds. Emma Frances followed in her mother's footsteps by also becoming a teacher. She taught and directed band students in the McMinn County Schools following her discharge from the WAC, where she was a member of the band. (Courtesy of Byron and Gaines Harmon.)

Roy Woods, age three, is shown with baby sister Mabel. They were born in Concord to Albert Addison and his first wife, Lizzie Rodgers. The attire for children, especially young boys, seemed to be more confining than present-day clothing. Possibly they were not as energetic as boys are today. (Courtesy of Linda Laughlin Ford.)

It is seldom that five active children can gather to have a picture taken. These are the children of Andrew Lamar and Anna Cordelia Campbell. They are, from left to right, (first row) James Edward and David Alexander; (second row) Ellen, Ada Belle, and Elizabeth. They were joined later by two more siblings, Neta Lynn and John Steele Campbell. (Courtesy of Neta Campbell Lawhorn.)

The sons of William Henry Raby, from left to right, are Clifton and John with their mother, Adra Wheeler Raby. This was planned to be a very special family photograph as the three had dressed in their "Sunday best." Both boys had caps and were told not to wear them, but at the last second, Clif quickly put his cap on just as the photographer snapped the picture. (Courtesy of Carolyn Coker.)

Ray Roberts Hobbs, born in 1916 in Concord, was the son of Fred and Mabel Woods Hobbs. He loved being in school, especially when it was time for reading. "Miss Elsie" Llewellyn taught the children proper posture in reading class. (Courtesy of Linda Laughlin Ford.)

Ten-year-old Clair Ruth Hobbs is in costume for a program of expression and music presented in 1929 by Evelyn Boring and Fancher Smartt at Farragut Grammar School. Ruth was extremely shy, and it was thought that expression lessons would be helpful. Years later, Ruth said it never helped. (Courtesy of Linda Laughlin Ford.)

The children of William Austin and Annas Watt Montgomery pictured here are, from left to right, Ruth, James Austin, Elizabeth ("Beth"), and John Lee standing in the back. James Austin was in his last year of agriculture at the University of Tennessee when he died unexpectedly. John Lee earned his medical degree within nine years of graduating from Farragut High School. He finally became an ophthalmologist. (Courtesy of Julia M. Scott and Tucker Montgomery.)

Seven

EDUCATION

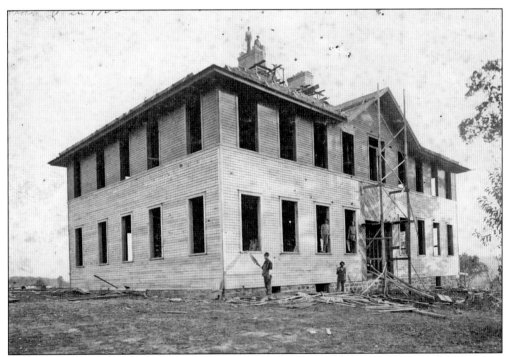

Farragut High School, well under construction by 1903, was the first high school built in rural Knox County. It was planned, built, and operated by the community until it could be deeded to Knox County. Contractor Martin Blosser can be seen working on the roof with son Solomon. (Photograph given to the Farragut Folklife Museum Collection by Zelda Blosser Ellenburg.)

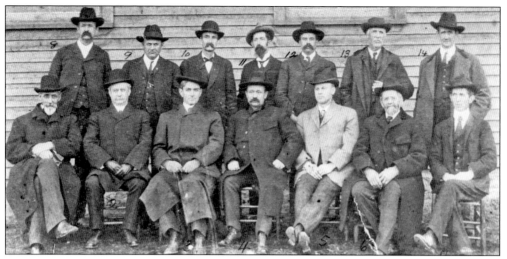

In 1902, a local committee planning the first high school in rural Knox County had as advisor-consultant University of Tennessee professor P. P. Claxton. Included with the basic committee were representatives from the smaller school districts. Other educators present at the final meeting were, from left to right, (first row) William Rule, editor of *Knoxville Journal and Tribune*; Brown Ayers, president of University of Tennessee; Prof. P. P. Claxton, teacher of teachers; Knox County superintendent of education Sam Hill; Prof. Seymour Mynders, state superintendent; Chris Stoltzfus, chairman of Farragut Board; and G. D. Russell, secretary of the committee; (second row) John B. Miller; John A. Duncan; James F. Woods Jr., district school board chairman; Charles N. Seaton; William A. Doughty; S. A. Taylor; and Dr. R. N. Tillery. Professor Claxton was invaluable in his leadership. (Courtesy of Farragut Folklife Museum Collection.)

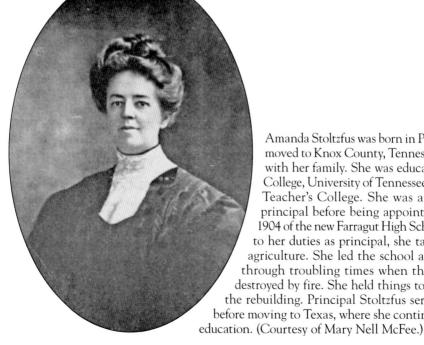

Amanda Stoltzfus was born in Pennsylvania but moved to Knox County, Tennessee, at age three with her family. She was educated at Peabody College, University of Tennessee, and Columbia Teacher's College. She was a teacher and a principal before being appointed principal in 1904 of the new Farragut High School. In addition to her duties as principal, she taught classes in agriculture. She led the school and community through troubling times when the building was destroyed by fire. She held things together through the rebuilding. Principal Stoltzfus served until 1908 before moving to Texas, where she continued a career in education. (Courtesy of Mary Nell McFee.)

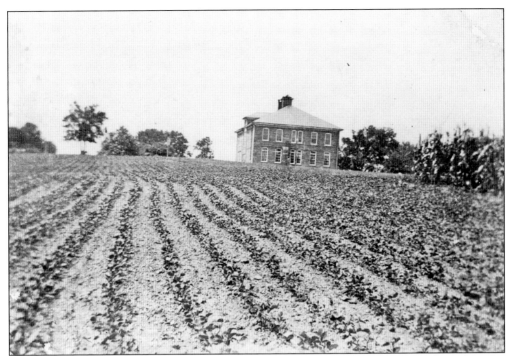

In 1907, Farragut's new brick building proudly stands near a field of soybeans planted by the agriculture students. Originally built as a high school, the first floor was later used as a grammar school. After fire destroyed the frame building in March 1906, classes were held in the vacant church nearby and other available buildings. (Courtesy of Marta O. Mills.)

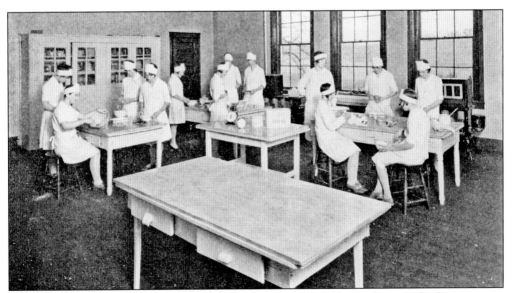

In the early 1930s, the domestic science class of Farragut High School is shown in food preparation. Dressed in white smocks and headbands, they appear to be more like a class of student nurses. The class studied the science of food and food preparation and how the content of the food affected the health of the family. The required apparel in the food's preparation lab was not in evidence in later years. (Courtesy of Mary Nell McFee.)

Addie Sypress Harvey, the son of James Robert and Jennie DeBusk Harvey, is shown in 1935 riding his pet steer, Old Jake. Harvey acquired the steer when it was young and used it at Farragut High School as his project in Future Farmers of America, a club for agriculture students. Eventually, the project came to an end, and Old Jake rode off to market, where he was sold for a high price, which helped to pay Harvey's tuition at the University of Tennessee. (Courtesy of Jennie Roberta Harvey Jones.)

Joe Davis of Campbell Station was Farragut School's first janitor from in 1903 until his death in 1927. One of his duties at the school was plowing the fields in preparation for the various crops by the students as they studied agriculture. He was loved and respected by students and teachers. He was buried by his wife, Mary, in Pleasant Forest Cemetery. (Courtesy of Farragut Folklife Museum Collection.)

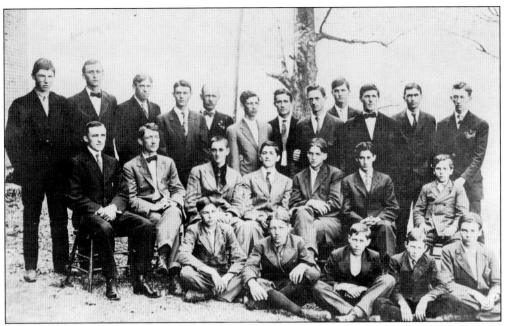

Members of the 1908 Farragut High School Boys Club were taught to argue but in a more educated manner called debate. Their opponents were members of the Girls Club. The Boys Club was sponsored by Principal Adams Phillips. One of the most interesting and heated debates with the Girls Club was on the question "should women be allowed to vote?" Guess who won. (Courtesy of Mary Nell McFee.)

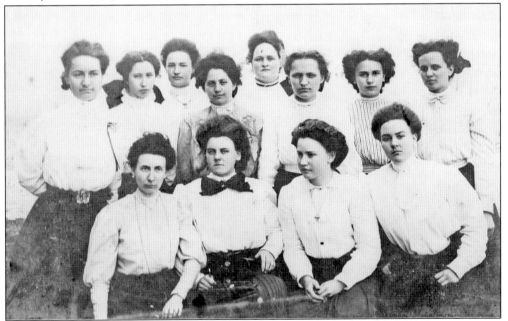

The Girls Club of Farragut High School of 1908 was called Ethonian. The students were interested in public speaking and the art of debating. They had equally qualified opponents from the Boys Club. This helped to prepare many of the young ladies who became teachers. (Courtesy of Mary Nell McFee.)

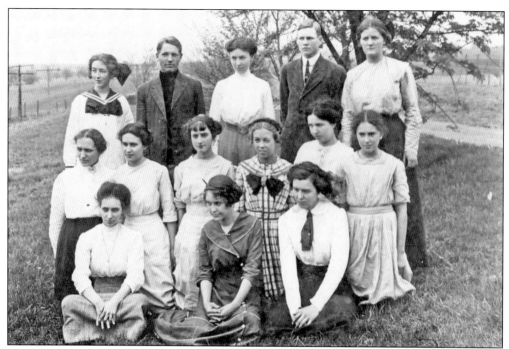

The 1912 music class at Farragut High School had only two young men to sing the bass and tenor. Farragut High School offered many enrichment courses with highly qualified teachers. Class members included Cleo Nelson, Edna Winfrey, Neta McFee, Inez McSpadden, Irene Anderson, Mary Gambill, Ruby McSpadden, Lida Belle Gambill, Fred McFee, Will Woods, and Alice Mills. Only 13 were photographed of a class with 19 on roll. Alice Mills lived to enjoy her 110th birthday. (Courtesy of Mary Nell McFee.)

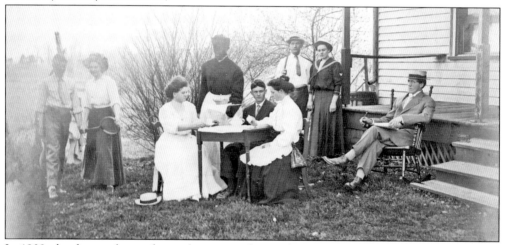

In 1909, the drama chosen for graduation week was the romantic comedy *Next Door*. Drama presentations were an extension of class work in public speaking and debate, except more fun. Cast members are shown during practice at the Doughty house on the adjoining farm south of the school. From left to right are (seated) Julia Doughty, Charles Doughty, Lucille McBath, and Treel Taylor; (standing) Roy Boyd, Lorena Hackney, Frank McFee, James Herron and Irene Woods. In her teaching career spanning many years, Irene was known as a drama coach not only for schools but for community presentations as well. (Courtesy of Byron and Gaines Harmon.)

This 1960s photograph of Irene Woods Reynolds is the image many students of Farragut, Bearden, and Catholic High Schools would most readily recognize. Irene taught 41 years in Knox County schools, continuing several more years at Knoxville Catholic High School. She took her first teacher training course while a student at Farragut High School, which qualified her to teach after graduation. (Courtesy of Byron and Gaines Harmon.)

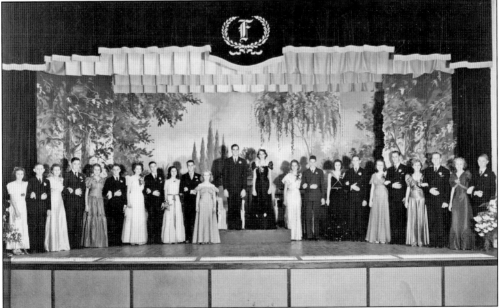

The Farragut High School royal court, grades 7 through 12, is shown in 1939 in the new freestanding auditorium. One girl chosen from each homeroom raised money for the school by collecting a penny for each vote. The girl with the greatest number of votes became the queen. Margaret Henderson, a senior, was crowned by Delight Snyder, the previous year's queen. She stands to the right of the king, Donald Jett. (Courtesy of Farragut Folklife Museum Collection.)

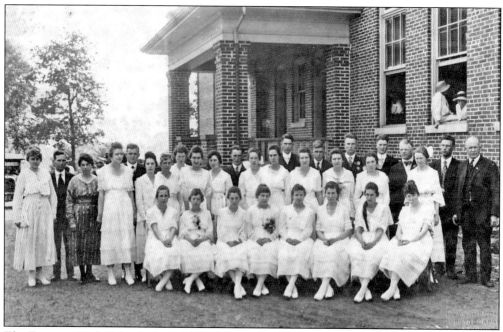

The Farragut High School class of 1918, pictured at the rear of the school, included 21 young women and only 7 young men. Whether or not World War I made a difference in the low number of males is not known. This is the largest number to graduate since the first class of 1908, which had only two women. (Courtesy of Mary Nell McFee.)

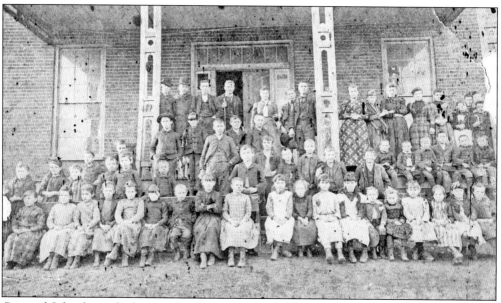

Concord School was the largest of the district schools. This picture was taken in the late 1890s as the students found a place on the steps and the porch of the Masonic hall. Their teacher, Andrew Lamar Campbell, stands fourth from the left on the back row. He is holding a pointer. (Courtesy of John Steele Campbell II.)

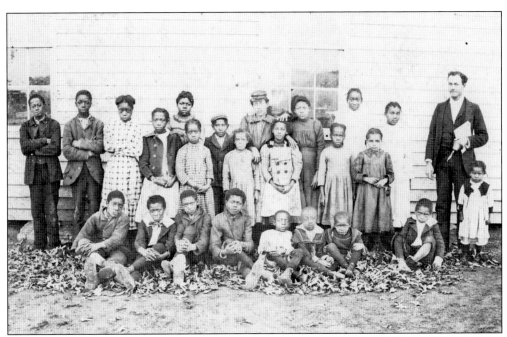

Concord School for Colored Children was organized as early as 1883, which was several years before Farragut High School was planned. There were few schools in the rural area for African Americans, and children from several miles away struggled to attend. The photograph of the students with their teacher, Will Hardin, was made on December 1, 1900, by Henry Franklin Smith of Concord. (Courtesy of Farragut Folklife Museum Collection.)

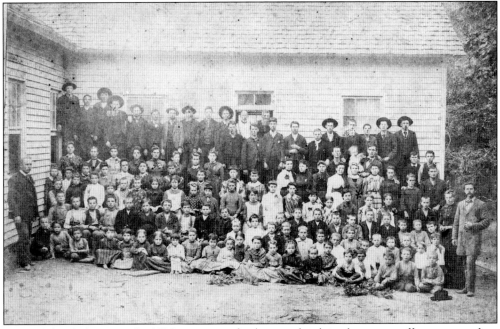

Union School, shown in the 1890s, was one of only two schools in the area to offer any secondary grades. Courses were offered to the 11th grade. This accounts for the heavier enrollment as compared to other schools. (Courtesy of Carl Nelson Bacon.)

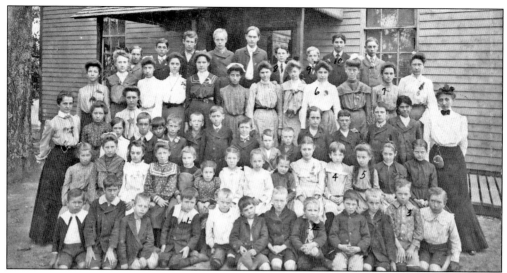

Lovell School had an enrollment of 65 with two teachers. Some of the students came from Campbell Station, while most were from the Lovell and Mabry Hood Roads area. Lovell School remained open for a few years after Farragut School was in session. (Courtesy of Mary Nell McFee.)

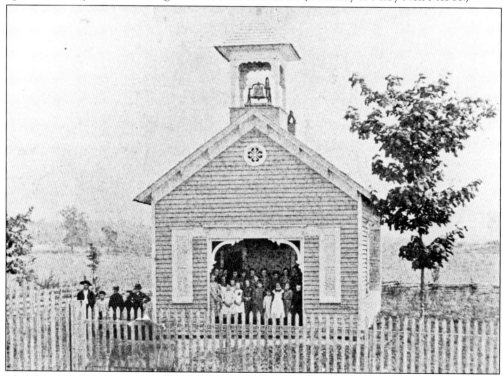

The three Russell sisters, daughters of Samuel Love Russell and Samira Ann Amanda Rodgers Russell, operated a private school on the east side of Olive Street at the crest of the hill. Their father built the school building for them. Alice was the teacher/principal. Her sister Jean taught also, but Lizzie liked to stay home and keep house more than teach. The school had an excellent reputation and served the Concord area several years after Farragut School opened. (Courtesy of Mary Nell McFee.)

Floyd Thomas McBee was appointed principal at Farragut Elementary School in 1938 and remained in that position until his retirement in 1973. He earned both his bachelor of science and master's degrees in education from the University of Tennessee. Born in 1905 and reared in Corryton, Knox County, he attended Gibbs High School, where he played basketball and baseball. (Courtesy of Libby McBee Haynes.)

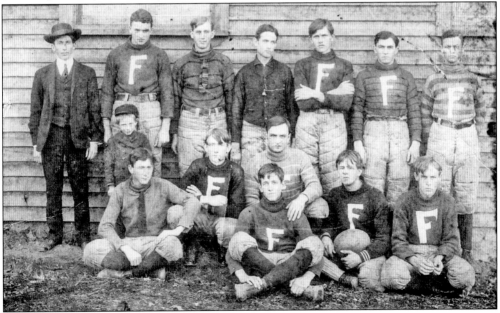

Farragut High School's first football team was organized by Ralph Stoltzfus in 1905. All the equipment was destroyed when the building burned in 1906, before the team had a chance to play against other teams. Another team was not organized until 1947. (Courtesy of Kathlyn Boring Davis.)

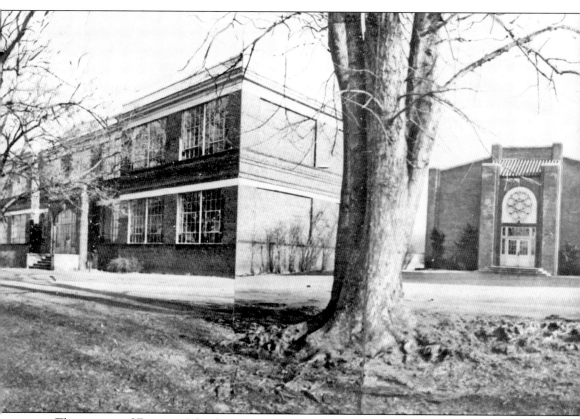

The campus of Farragut Schools is shown here in 1946. All buildings are constructed in brick with the exception of the two-bedroom frame cottage, probably built in the early 1920s for the principal's residence. To comply with fire codes, fire escapes were added to the second-floor classrooms of the high school building (extreme right) several years after this picture was made.

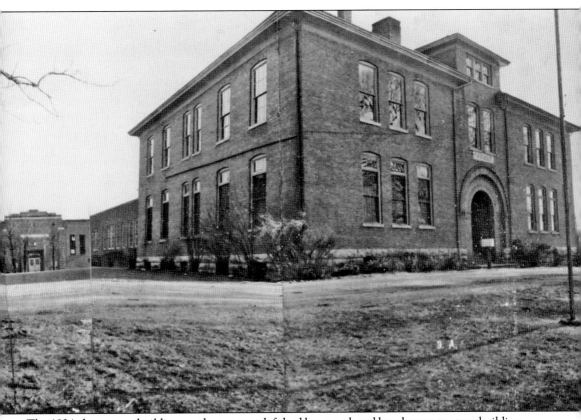

The 1924 elementary building on the extreme left had been replaced by a large one-story building by 1949. The free-standing auditorium, built in 1938, can be seen on the left. There is a shopping center currently on this site. (Courtesy of Farragut Folklife Museum Collection.)

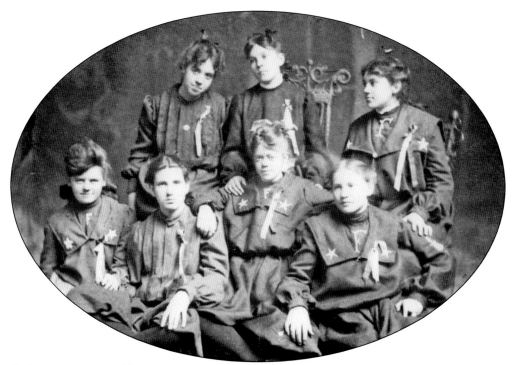

Girls were not omitted from the athletic program at Farragut High School, but it is difficult today to imagine how the players of the 1907 basketball team played in the uniforms of the day. Christine Stoltzfus (center front) is the only person identified in this photograph. She was the sister of Amanda Stoltzfus, an early Farragut High School principal. (Courtesy of Mary Nell McFee.)

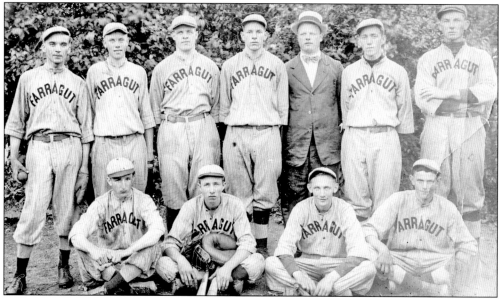

A Farragut High School baseball team is shown in this 1915 photograph. From left to right are (first row) Frank Russell, Frank Llewellyn, Nathan Henson, and unidentified; (second row) Pat Wells, Sam Doughty, Jim Luck, Walter Woods, coach Felton Luck, Charles Hinton, and Glenn Smith. (Courtesy of Vickie Owens Rosenberger.)

Eight

RELIGION

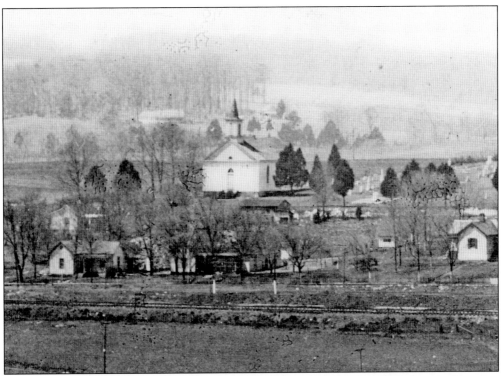

Concord Cumberland Presbyterian Church was located on the west side of the Masonic Cemetery looking south down Church Road. Both the Methodists and Concord Presbyterians met in the building at different times when they didn't have their own building. After it was no longer used as a church, the salvaged lumber was used to build a house at the bottom of the hill at Church Road and Front Street. (Courtesy of Farragut Folklife Museum Collection.)

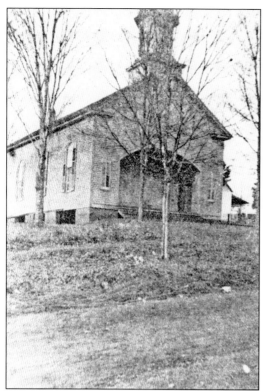

The Concord Presbyterian Church was built in 1877 of the southwest corner of Clay Street and Second Drive. The building site was donated by Joseph M. Galbraith. Before having this building, the Presbyterians experienced being without a place to worship until the Concord Cumberland Presbyterians invited them to join them at their church, located at the western edge of the Masonic Cemetery. The Concord Presbyterian Church accepted their hospitality until their building was ready. (Courtesy of Farragut Folklife Museum Collection.)

Teacher Jean Russell stands beside her class of women of mixed ages in the Union Sunday school. The photograph by Henry Franklin Smith was made of members on the steps of Concord Presbyterian Church in 1915. Being without a building of their own until 1920, the Concord Methodist members were welcomed to worship in the Concord Presbyterian Church. The union lasted 44 years. (Courtesy of James Welch Woods.)

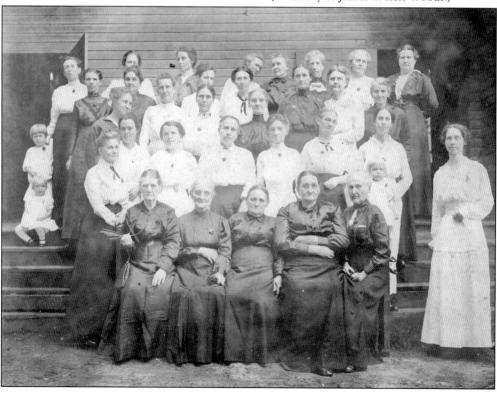

Pleasant Forest Church and cemetery are seen from Concord Road about 1915. The white frame building replaced the brick church that was destroyed when Civil War soldiers used the bricks for ovens while encamped there. After the war, the surviving membership could not hold together, as many former members had joined other churches. The church remained vacant for many years before being razed. The salvaged lumber was used in the building of a small stable on the adjoining farm. (Courtesy of John Steele Campbell II.)

In the early 1900s, members of the Cedar Bluff community gathered for a baptizing at the abandoned quarry behind the present Christian Academy of Knoxville on Dutchtown Road. Neither the minister, the person being baptized, nor any of the spectators were identified. The quarry walls with the protruding boulders made a natural arena for the audience. (Courtesy of Clyde Floyd.)

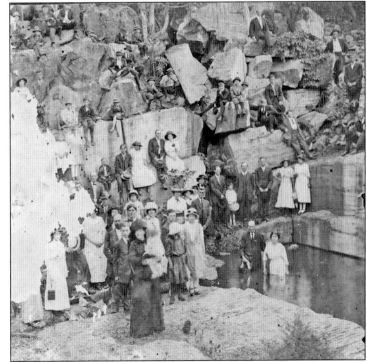

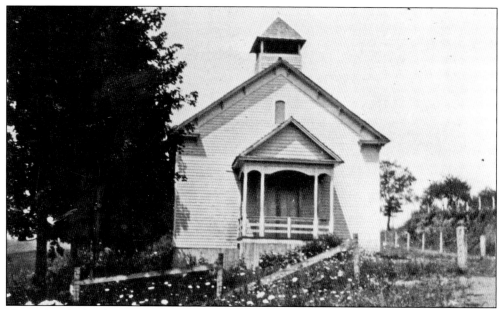

Virtue Cumberland Presbyterian Church celebrated its 121st anniversary in 2008. John Marshall Montgomery donated the land on the corner of Evans and Virtue Roads for the original church site. Prospect Chapel was the name chosen for the new church. By 1892, the name was changed from Prospect Chapel to Virtue Cumberland Presbyterian Church. To accommodate the growth in membership, a larger church was built nearby. (Courtesy of Julia M. Scott and Tucker Montgomery.)

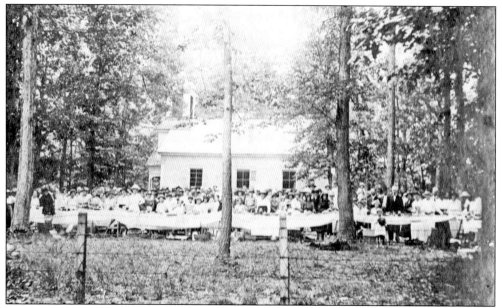

Union Cumberland Presbyterian Church had dinner on the grounds in the early 1900s for a homecoming celebration. White tablecloths were brought out for the special occasion. A large crowd attended. At that time, the church was located on Union Road in what is now Farragut. A much larger church was built recently on Everett Road, a short distance to the west. (Courtesy of Farragut Folklife Museum Collection.)

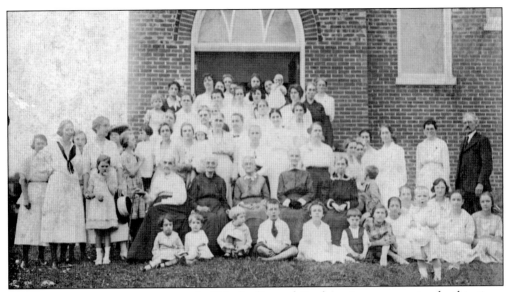

The home mission group composed of Methodist and Presbyterian women stands, this time, on the steps of the new Concord Methodist Church. At least three generations are pictured in the summer of 1920. The Methodist minister, Rev. James E. Fogleman, and Jean Russell serve as leaders of the group. (Courtesy of James Welch Woods.)

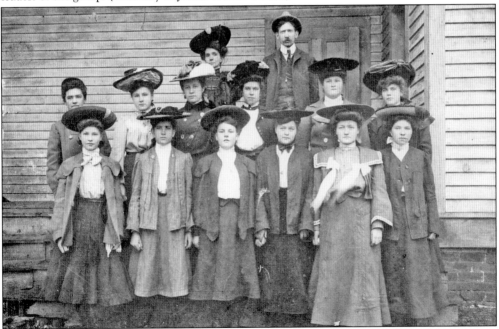

Teacher Mayme Low Galbraith, with the union Sunday school class of Methodist and Presbyterian teenage girls, is shown on the steps of Concord Presbyterian Church about 1907. Being without a building, the Methodists were asked to join the Presbyterians in a union Sunday school. Members are, from left to right, (first row) Lorena Hackney, Nanny Houston, Irene Woods, Beulah Bailey, Carrie Heft, and Ida Kincer; (second row) Lucy Winfrey, Mabel Woods, Jennie Galbraith, Mattie Smith, Stella Miller, and Nell Bonham. Standing behind the class are Mayme Low Galbraith and Sunday school superintendent Joe Brown. (Courtesy of Mary Nell McFee.)

Shady Grove Baptist Church was located in southwest Knox County on what is now Northshore Drive at Harvey Road. Thomas Harvey helped to organize the church in the early 1800s and became its first preacher. Oney, Thomas's son, deeded land for the church and cemetery. Other ministers serving the church were Rev. John Holder and, more recently, Rev. Oscar Lawhorn. The first church was made of logs, as most were in those early years. (Courtesy of Jennie Roberta Harvey Jones.)

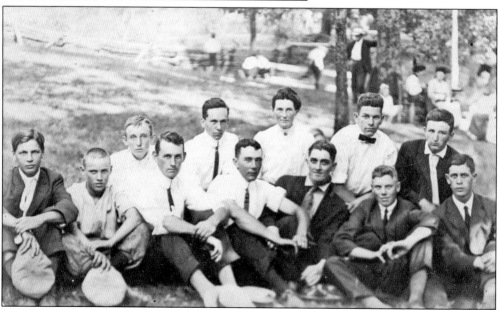

The young men's class of the Concord Union Sunday school is pictured about 1916 at Vance's Spring during the annual picnic. (Courtesy of Byron Harmon.)

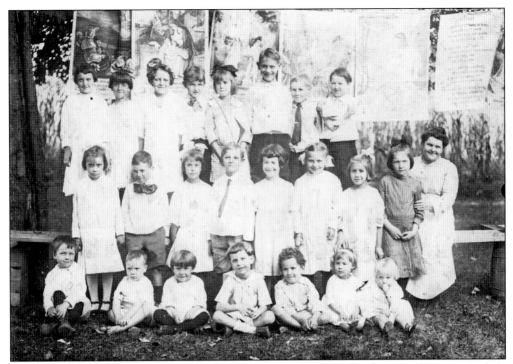

Twenty-three Presbyterian and Methodist children of the union Sunday school pose with their teacher, Minnie Vance, about 1914. The children's ages vary from preschool to third grade. (Courtesy of Farragut Folklife Museum Collection.)

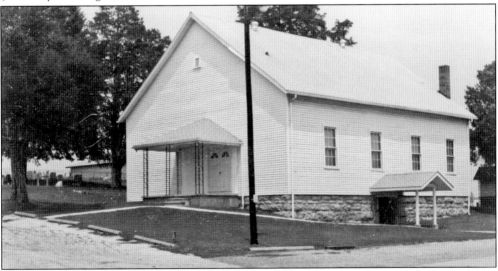

The Concord Mennonite Church was built about 1874 at the corner of the John Stoltzfus farm at Dutchtown and Lovell Roads. John, often referred to as "Tennessee John," was considered the elder statesman. He had led several Mennonite families to Tennessee from Pennsylvania in 1871. Being the bishop of the congregation, he built a meetinghouse and paid for it himself. He also promoted a Sunday school. These labeled the Concord group as liberals, as opposed to the very conservative bishops of Lancaster County, Pennsylvania. (Courtesy of Farragut Folklife Museum Collection.)

Jean Russell's Sunday class for young women posed for their class photograph while attending a union Sunday school picnic at Vance's Spring in Concord. It is especially interesting to compare the ladies' attire for a picnic in the early 1900s with what ladies would choose to wear to a church picnic in 2008. (Courtesy of Barbara Hall Beeler.)

In the late 1930s, Concord Presbyterian Church had a facelift. When built in 1877, it was all sanctuary without a provision for classrooms. With a few construction adjustments, more room was made. It was at this time that the church sponsored a youth church orchestra, which held practice each Sunday afternoon to be ready to perform at other churches. It was an interdenominational effort. (Courtesy of Farragut Folklife Museum Collection.)

Concord A.M.E. Zion Church, established in 1872, celebrated 135 years at its annual homecoming on May 27, 2007. The first pastor was F. P. Moulden of the Concord community. The original building was described as an outstanding achievement of its day, although it was rebuilt in the mid-1940s. On April 12, 1970, the church and former school building located on Loop Road were destroyed by fire. After purchasing the adjoining lot, where the school had stood, the small but dedicated membership proceeded to rebuild. (Courtesy of Helen Varner Trent.)

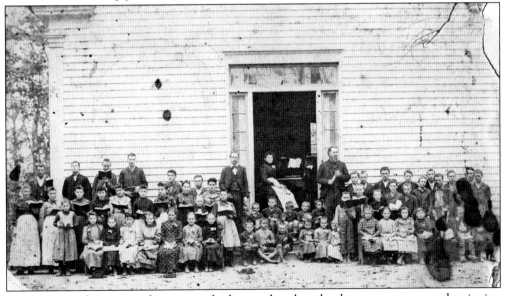

Minnie Copenhaver is at the organ, which was placed at the door to accompany the singing school. Children participated in this activity at Union School about 1900. Teachers and a few adults were on hand to see that each child had a songbook. (Courtesy of Paul Russell Swan.)

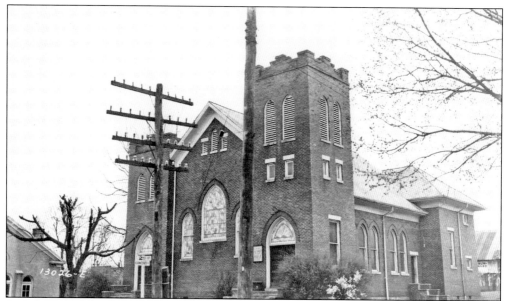

In the summer of 1920, members of the Concord Methodist Episcopal Church South were finally worshipping in their own new building, erected on the southwest corner of Second Drive and Concord Road, now Olive Road. At the rear of a long sanctuary were 10 open classrooms, five on the ground floor with stairways on each side leading to five more classrooms on the balcony. After accepting the hospitality of the Concord Presbyterian Church for nearly 44 years, there was a touch of sadness in the transition. The Methodists were overjoyed to have their own home but sad to leave their Presbyterian friends after such a long union. (Courtesy of Bill S. Dunlap.)

The Reverend Rufus Gaines Reynolds, born in Anderson County, was one of three brothers to become Methodist ministers. In his assignment to Concord from 1911 to 1914, he met Martha Irene Woods. They married in 1918. Their two daughters were Emma Frances and Martha Gaines. Reverend Reynolds died on July 4, 1933, while preaching a revival. Besides being assigned to Concord Methodist Church twice, Reverend Reynolds served churches in Big Stone Gap, Virginia; Cleveland, Tennessee; Sevierville; Lenoir City; and Magnolia Avenue in Knoxville. He was well liked wherever he served. (Courtesy of Emma Frances Reynolds.)

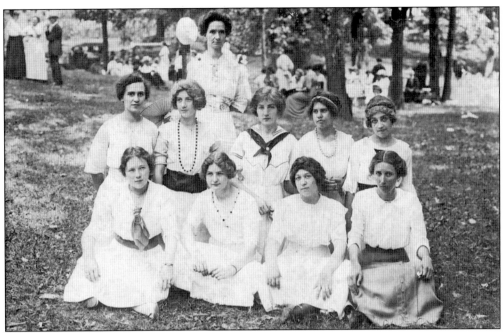

This young ladies' class and teacher of the Concord Union Sunday school were photographed by Henry Franklin Smith in 1915 at the annual picnic held at Vance's Spring. During the spring and summer months, it was always a popular place for outings. Vance's Spring and the farm west of the Calloway farm were taken by the backwaters of Fort Loudoun Lake in 1943. From left to right, class members are (first row) Jean McNutt, Hallie Hackney, Ruby Koon, and Lucy Hobbs; (second row) Ruby McSpadden, Dean Galbraith, Ellen Belle Russell, Evelyn Thompson, and Lila Bell. Standing behind is their teacher, Mayme Low Galbraith. (Courtesy of Samuel Hobbs Hart.)

The old Concord Baptist Church was erected on Concord Road between Second and Third Drives. The first service was held in 1890, soon after it was built. Services were held there for 38 years until 1928, when Crichton Memorial Baptist Church was built on Front Street (Lake Ridge Drive) and Concord (now Olive) Road. The building and lot are now owned by Barbara Hall Beeler and her son Tim Beeler. This photograph was taken in 1900 by Barbara's grandfather, Henry Franklin Smith. (Courtesy of Barbara Hall Beeler.)

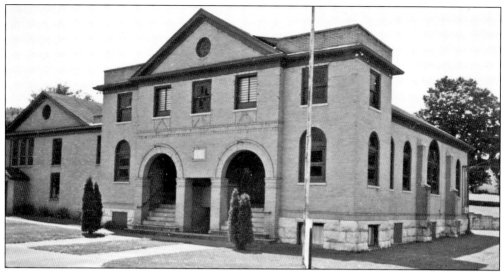

In 1927, the lot on the corner of Front Street and Concord (now Olive) Road was purchased by the trustees of Concord Baptist Church. They built a beautiful new church with a baptismal pool. The inclined floor with theater-style seating was certainly different from the benches or pews seen in the older Concord churches. According to the marble plaque at the entrance, the building was completed and dedicated in 1928 to the memory of Crichton Bevins, who died as a young child. The church was named Crichton Memorial Baptist Church and retained that name until it was sold in 1966 as the Baptists established their church in Farragut. (Courtesy of Gene McNutt Abel.)

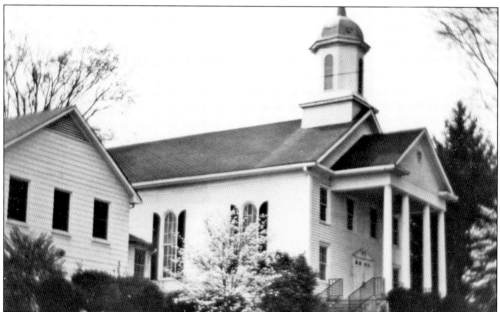

In the early 1960s, changes were again made to the front of the Concord Presbyterian Church. A new entrance was added. Earlier in the 1950s, an education wing was added on the south side. A manse was built about 1945 on a lot at the rear of the church. It was constructed from the salvaged lumber of member J. K. Vance's house, razed when the property was to be inundated by the backwaters of Fort Loudoun Lake. (Courtesy of Farragut Folklife Museum Collection.)

Nine

MILITARY

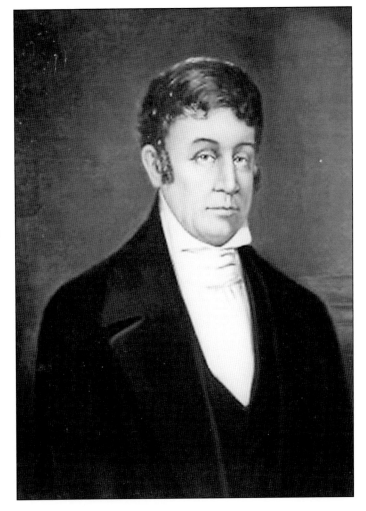

Archibald Roane fought in the Revolutionary War and was present during the surrender of Cornwallis at Yorktown. In 1796, he represented Jefferson County at the convention to frame the Tennessee Constitution. In 1801, he was elected Tennessee's second governor, but he was defeated by John Sevier in his second run for that office. Roane died on his estate at Campbell Station and is buried nearby in Pleasant Forest Cemetery on Concord Road. (Courtesy of Farragut Folklife Museum Collection.)

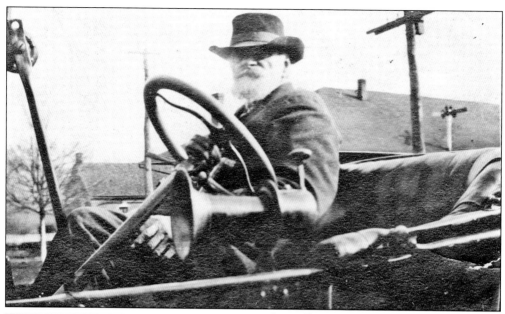

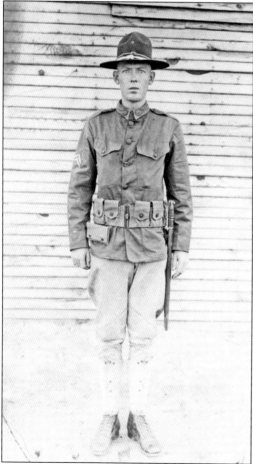

James Farmer Woods was born in 1833 in Monroe County, Tennessee. During the Civil War in 1862, he took his wife, Martha Ann McQueen Woods, and three young children to her parents' house in Raybun County, Georgia, where he enlisted in the Confederate army. He was in Company F, 52nd Georgia Regiment. He was captured at Vicksburg in November 1863. After being released, Woods rejoined his company and again was captured in July 1864 at Resaca, Georgia. After the war, he went to Raybun County to get his wife and children, only to find another son had been born. The family returned to Tennessee. (Courtesy of James Welch Woods.)

World War I soldier Clarence "Queenie" Hobbs from Concord was known as Constable Hobbs, the local law enforcement officer. Crime was low for the area, with only a few petty thefts. During the 1930s, an overnight robbery (break-in) occurred in a new grocery store recently opened. Not having highly sophisticated detection equipment, Hobbs called on the Knox County sheriff to bring out his best. It took only two hours for the bloodhound to track the alleged perpetrator's tracks to his front door. (Courtesy of Farragut Folklife Museum Collection.)

Walter Gordon Woods, son of James Farmer Woods Jr. and Emma Seaton Woods, joined the navy in 1918 and was stationed in New Orleans for basic training. He is shown holding Kathlyn Boring, a cousin, while home on leave. (Courtesy of Hayley Gordon Mills.)

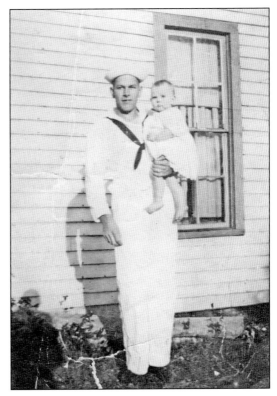

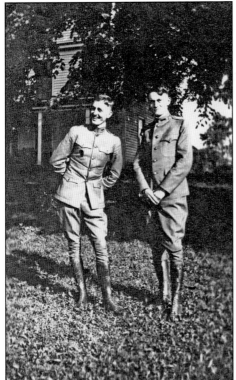

Standing at left is either Rob or his identical twin Roy Boyd with good friend Roy Vance, both on leave during World War I. The Boyds graduated from Farragut High School in 1911 and Vance in 1913. Years later, Roy Vance became Tennessee commissioner of education. (Courtesy of Gene McNutt Abel.)

117

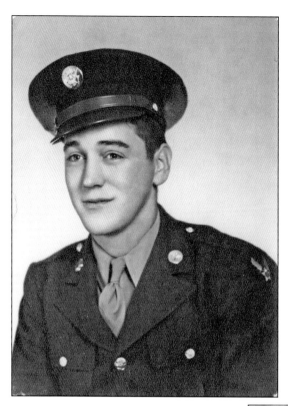

Charles Baker Irwin was born on December 13, 1921, to Charles and Grace Baker Irwin. He was their only son of six children. A graduate of Farragut High School in 1939, Charles was entering his third year in agriculture at the University of Tennessee when he volunteered for service in the U.S. Army Air Force on August 11, 1942. He was killed on a bombing raid over Gelsenkirchen, Germany, on August 12, 1943. Staff Sergeant Irwin was buried with 8,300 men and women in the Netherlands American Cemetery in the village of Margarten, Holland. (Courtesy of Nell Irwin Strange.)

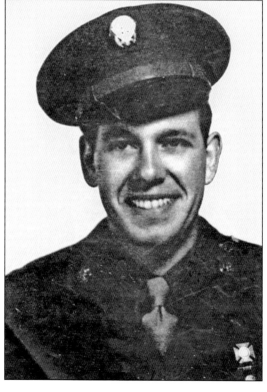

Robert Glen Campbell, son of Glen and Clara Campbell, grew up in the Virtue community. He was a descendant of "Elder" David Campbell, the cofounder of Campbell Station. The young soldier was killed on January 20, 1945, at Trier, Germany. (Courtesy of Farragut Folklife Museum Collection.)

S.Sgt. Joseph Andrew Shell was with the 314th Infantry when he was killed in Italy on November 13, 1944. Joe was the son of Edward Sr. and Grace Perkinson Shell, who were living at White Pine, Tennessee. Shell Sr. was a telegrapher and station agent for the Southern Railroad. It was the father who took the message from the War Department of his son's death. Within a few months, the Shell family moved back to Concord. (Courtesy of Malcolm Shell.)

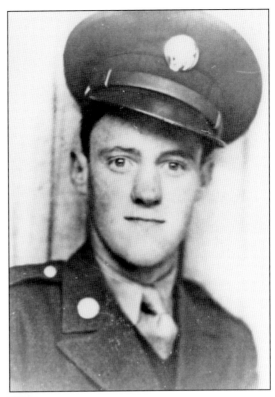

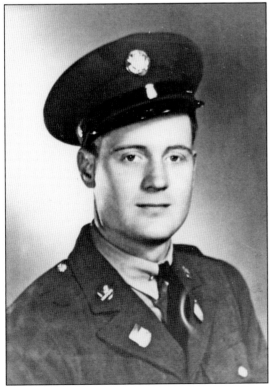

Carl Cicero Shell, son of Edward Sr. and Grace Perkinson Shell of Concord and White Pine, Tennessee, served in the 761st Engineers' Battalion in Italy. He and his brother, Joseph Shell, kept in touch and were planning to meet, but when that time arrived, Carl found his brother had been killed the day before. (Courtesy of Malcolm Shell.)

Carl Kincer, son of Michael G. Kincer of Concord, was inducted in the air force and was sent to South Florida for basic training. At one point, he became ill and made a visit to the infirmary. While there, a childhood eye injury was noticed. He pleaded to stay in service but to no avail. He was sent home to the farm, where he was most needed and any pre-training was unnecessary. (Courtesy of Rebecca Goins.)

Harvey Crockett Kincer enlisted in the U.S. Army Air Force and passed the written test qualifying him for cadet school, but he could not be a pilot because of a physical disability—flat feet. He had basic training in Miami, Florida, then was sent to Gailsburg, Illinois, where this photograph was taken. He was sent to Sheppard Field, Texas, became ill, and was admitted to the hospital. While there, Dr. John Lee Montgomery of Virtue helped Crockett. Later Kincer fell and broke an ankle, so he was honorably discharged and sent back to the farm where he was desperately needed in 1944. (Courtesy of Cleta Kincer Kelley.)

Roscoe Conklin Irwin Jr. was the son of R. C. Sr. and Lula Kincer Irwin of Concord. From 1940 to 1945, Private 1st Class Irwin was at bases in Ohio and Arkansas. By October 1945, Corporal Irwin was in division headquarters of the 80th Infantry writing from Czechoslovakia. In December, he wrote the family from Germany that he was still driving a "colonel" in a civilian car. He later explained that the colonel was General Patton. (Courtesy of Carolyn Irwin North.)

Jackson Gaines Thompson, the son of George and Eleanor Morton Thompson of Mabry Hood Road, Concord, was a graduate of Farragut High School. He attended the University of Tennessee, where he was in ROTC (Reserve Officers Training Corps). He was commissioned a second lieutenant in the U.S. Army infantry during World War II and was stationed at Fort Leavenworth, Kansas. He was on inactive service for 28 years, attaining the rank of lieutenant colonel. Jack, 91 years old, lives with his wife, Jane, off Lovell Road. Jack is an avid bridge player and plays regularly. (Courtesy of Jackson G. Thompson.)

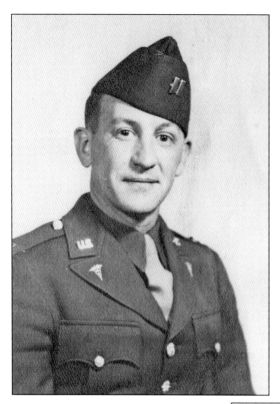

Malcolm Freels Cobb, born in the Karns community, graduated from medical school in 1933. He began his practice in 1934 at Concord, married Bessie Lloyd, and had two children, Malcolm Jr. and Julia Beth. During World War II, Dr. Cobb, with the rank of captain, served as battalion surgeon with the famed Spearhead Armored Division. He was awarded the Silver Star and five Battle Stars. After his discharge, he returned to his practice in the Concord-Farragut area, where he retired in 1982. (Courtesy of Julia Cobb-Freer.)

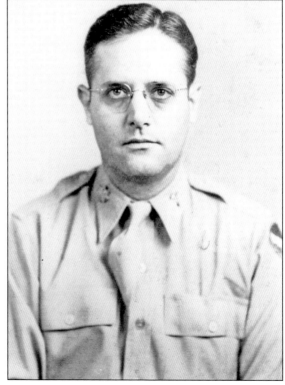

In early 1942, even though married with two young children, Dr. John Lee Montgomery offered his services and was inducted with the rank of captain in the U.S. Army Air Force. He was sent to Shepherd Field at Wichita Falls, Texas, where he was assigned to the eye clinic. His job was to examine new recruits for glasses or other eye conditions. After four years, Dr. Montgomery was discharged in 1946. (Courtesy of Julia M. Scott and Tucker Montgomery.)

Mary Margaret Smith, the daughter of Henry and Margaret Rodgers Smith, was one of two young women from Concord to volunteer for service during World War II. Smith was inducted in the Women's Auxiliary Army Corps (WACs) on August 27, 1942, at Fort Oglethorpe, Georgia. She was sent to Des Moines, Iowa, with the rank of staff sergeant. Then she transferred to the division of discharges and deaths at the Frances E. Warren Air Base in Cheyenne, Wyoming. Staff Sergeant Smith was honorably discharged in 1945 but remained there as a civilian servant employee until her retirement in 1973. (Courtesy of Barbara Hall Beeler.)

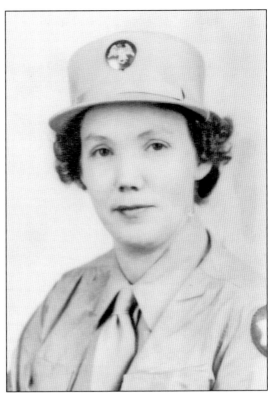

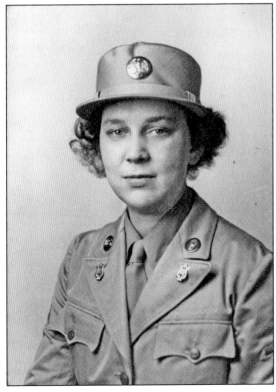

Emma Frances Reynolds, the daughter of Irene Woods Reynolds of Concord, served in the Women's Auxiliary Army Corps band during World War II. The band played for bond drives, visited hospitals to play for recovering servicemen, and performed on docks for incoming service units. After the war, Frances taught and directed bands at schools in McMinn County, Tennessee. (Courtesy of Byron and Gaines Harmon.)

David Alexander Campbell, the first son of Andrew Lamar and Anna Cordelia Campbell, was the great-grandson of "Elder" David Campbell. David enlisted in the U.S. Marine Corps after the Pearl Harbor attack. He was trained as a radar operator during basic training and was sent to New Zealand, a staging area for island invasions of the Pacific. Campbell was in the 3rd Marine Division, and his unit was involved in the invasion of the island of Bougainvillea and remained there for four years. David's picture was taken on a street in New Zealand. (Courtesy of John Steele Campbell II.)

James Edward Campbell was the second son of Andrew Lamar and Anna Cordelia Campbell. In 1940, Edward enlisted in the U.S. Naval Air Corps. After completing his course, he was sent to Glenview in Chicago, where he taught the new enlisted men and helped them earn their wings. After two years, he was sent to the Philippines, where he flew 51 missions before being transferred to the ground as an observer. (Courtesy of John Steele Campbell II.)

John Steele Campbell II, the youngest of three sons of Andrew Lamar and Anna Cordelia Campbell, was inducted into the army in 1950. He served in the 4th Infantry after basic training in Fort Benning, Georgia, and his unit was sent to Europe, where they faced the Russians for six months. On furlough, Campbell visited Rome, where he toured the Vatican and the Sistine Chapel. He especially enjoyed the food there. (Courtesy of John Steele Campbell II.)

James Welch Woods, the son of Walter Gordon and Ziza Welch Woods, was born in Concord. He was in his third year of majoring in chemical engineering when drafted in 1943. He served with the water purification unit of the 336th Engineers' Battalion, which moved through France, Germany, and Belgium. After the war, Woods graduated from the University of Tennessee and worked in metals and ceramics at Oak Ridge National Laboratory until his retirement in the early 1980s. (Courtesy of James Welch Woods.)

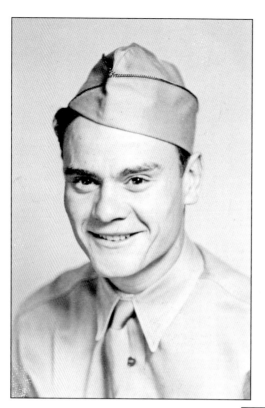

M.Sgt. Bruce Kermit Harvey, a son of James Robert and Jennie DeBusk Harvey, attended Farragut High School before entering service during World War II. He joined the U.S. Army Air Force and became a meteorologist while stationed in Hawaii. After service, he became a weatherman in Tampa, Florida. (Courtesy of Jennie Roberta Harvey Jones.)

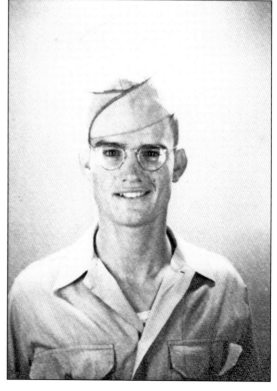

Pvt. Robert Dexter "Jim" Harvey, a son of James Robert and Jennie DeBusk Harvey, was in the German campaign during World War II. He was in a Ranger division. (Courtesy of Jennie Roberta Harvey Jones.)

Harlan Frederick Dunlap, better known as Chester, grew up in Concord. He was valedictorian of his 1940 Farragut High School class. Dunlap served in the marines during World War II. After the war and finishing college, Dunlap was an engineer at Oak Ridge National Laboratory. (Courtesy of Bill S. Dunlap.)

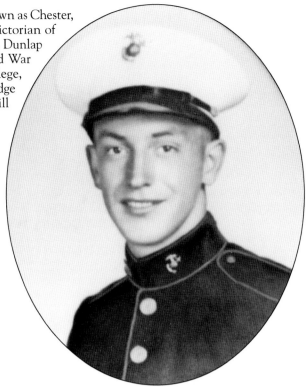

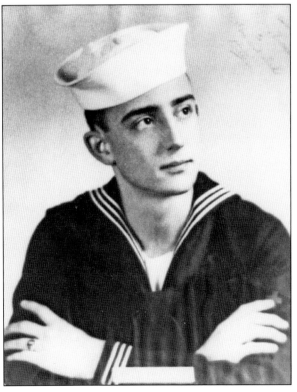

Billy Samuel Dunlap joined the U.S. Navy soon after graduating from Farragut High School in 1943. After basic training, he was on a hospital ship in the Pacific theater and served under Alene Duerk, who later became the first female admiral. He returned to the Concord community after the war to finish his education. (Courtesy of Harlan Frederick Dunlap.)

DISCOVER THOUSANDS OF LOCAL HISTORY BOOKS FEATURING MILLIONS OF VINTAGE IMAGES

Arcadia Publishing, the leading local history publisher in the United States, is committed to making history accessible and meaningful through publishing books that celebrate and preserve the heritage of America's people and places.

Find more books like this at
www.arcadiapublishing.com

Search for your hometown history, your old stomping grounds, and even your favorite sports team.

Consistent with our mission to preserve history on a local level, this book was printed in South Carolina on American-made paper and manufactured entirely in the United States. Products carrying the accredited Forest Stewardship Council (FSC) label are printed on 100 percent FSC-certified paper.

MADE IN THE USA